a comprehensive guide to digital close-up photography

AVA Publishing SA
Switzerland

An AVA Book
Published by AVA Publishing SA
Chemin de la Joliette 2
Case postale 96
1000 Lausanne 6
Switzerland
Tel: +41 786 005 109
Email: enquiries@avabooks.ch

Distributed by Thames & Hudson
(ex-North America)
181a High Holborn
London WC1V 7QX
United Kingdom
Tel: +44 20 7845 5000
Fax: +44 20 7845 5055
Email: sales@thameshudson.co.uk
www.thamesandhudson.com

Distributed by Sterling Publishing Co., Inc.
in the USA
387 Park Avenue South
New York, NY 10016-8810
Tel: +1 212 532 7160
Fax: +1 212 213 2495
www.sterlingpub.com

in Canada
Sterling Publishing
c/o Canadian Manda Group
One Atlantic Avenue, Suite 105
Toronto, Ontario M6K 3E7

English Language Support Office
AVA Publishing (UK) Ltd.
Tel: +44 1903 204 455
Email: enquiries@avabooks.co.uk

ISBN 2-88479-062-4

10 9 8 7 6 5 4 3 2 1

Design: Bruce Aiken
Picture research: Sarah Jameson

Production and separations by
AVA Book Production Pte. Ltd., Singapore
Tel: +65 6334 8173
Fax: +65 6334 0752
Email: production@avabooks.com.sg

a comprehensive guide to digital close-up photography

john clements

contents

Ilona Wellmann is based in
Gummersbach, Germany. A digital artist,
she captured this image on a 5Mp digital
compact, fitted with a 250D close-up
lens and a diffusing spot filter. Using
Photoshop, the image was slightly
cropped and the contrast adjusted, then
output as a 40x30cm inkjet print.

6	introduction
8	how to get the most from this book
1	**the digital mind-set**
14	definitions I
16	definitions II
18	definitions III
20	first moves
22	seeing it through
24	plug-in and power up
26	compact quality
28	serious kit
2	**digital basics**
36	starting position
40	close-up crop
44	simple life
46	natural look I
48	natural look II
50	play on words
54	anytime, anywhere
3	**intermediate levels**
60	just paper
62	underwater close-up
64	curve control
68	interpolation
70	moving impressions
4	**working with colour**
76	colour harmony
78	quick masks I
80	quick masks II
82	keeping the noise down
84	worlds within worlds
86	start to finish
88	getting your profile right
5	**working in mono**
96	desaturate
98	monochrome up close
100	lab colour
104	something from nothing
6	**advanced imaging**
112	macro post-production
116	landscapes of the mind
120	continue to grow
122	layered hair
124	raw goodness
128	smooth tones
130	close-up art
132	mimicking film
	appendix
136	glossary
140	contacts
144	acknowledgements

introduction

What a wonderful world we live in. It provides inspiration in countless forms for photographers, covering limitless subjects. But it is close-up and its associated macro and micro photography that motivates so many. Though a necessary part of life in some scientific and medical professions, for the enthusiast, close-up photography is simply 'art' for its own sake.

One of the advantages of close-up subjects is that they are available at any time. In the home, in the studio, or on location, there are countless subjects whatever the weather and often the most rewarding are right in front of our eyes. For those not yet bitten by the 'bug', it is likely that you are looking but not seeing.

This book includes some macro, as well as close-up images, as many photographers, with the right equipment, naturally follow this route also. While traditional techniques and skills remain vital, with digital imaging there is so much that can now be done post-capture that we are seeing new 'worlds within worlds' via our computers.

From the professional to those just starting out, there is something for everyone in this book. It features images from photographers across the globe, examining what they have done and how. Extra information has been included where relevant, to further stimulate your ideas. It is my hope that you will enjoy this book not only when it is new, but as a source of inspiration for years to come.

Best wishes and good photography.

John Clements

'Sea Anemones' by Monika Sapek.

screengrabs

Often detailing the
exact settings used
for key stages of the
photo-editing
process,
screengrabs provide
a quick and
instructive visual
check with which to
follow the
proceedings.

how to get the most from this book

In this book, the techniques of close-up digital photography are presented in six chapters. Starting with an overview of digital imaging at various levels of skill, photographers outline how they tackle numerous subjects, both in-camera and during post-production. Key components of the modern digital workflow are considered in detail during subsequent chapters. We also focus on specific styles of close-up photography, including monochrome pictures and fine art imagery. A glossary at the end of the book explains some commonly used terms in the digital arena.

Each spread is self-contained and explains either how specific images have been created in depth, or gives a brief overview of the important steps to accompany a detailed look at a particular technique or feature. Helpful quotes from the photographer or author put a personal slant on the information presented. Everything is explained from the photographers' 'hands on' point of view, not just from a theoretical approach. The design allows you to dip into the book at any stage to gain useful insight, without necessarily having to read the chapters and spreads in order.

The featured work comes from both professional photographers and talented enthusiasts, and there is something for everyone no matter what their approach or starting point.

natural look I

quotations

The photographer adds his or her own thoughts in his or her own words.

introduction

An overview of the theme and techniques set out in the spread.

flow chart

A step-by-step outline of the main stages that the image has gone through is given in a flow chart. This allows a quick reference to the same or similar points of interest on different spreads. The flow chart also enables the reader to determine at a glance how simple or complex an image was to create.

Much macro, like many other types of photography, is best represented by giving an image a natural look, where any post-capture enhancements are not obvious. This can be achieved with small steps and limited adjustment values; tools to create surreal or conceptual images do not necessarily provide the optimum solution. The image here achieves what the photographer was looking for by showing the colours and wonderful forms of nature in which he specialises.

'First of all, we must be respectful of nature; it is necessary to take care of it.'

shoot

'Helicoverpa Armigera' created by nature and photography enthusiast Ramón Erezuma, who c it at the Urdaibai (UNES Biosphere Reserve in th Basque country in Spain has a fascination for the 'small beings who at firs not appreciated'. He us

enhance

Only a few minutes need be spent on post-captur in Photoshop using Breezebrowser as a plu and also using Nikon Ca software. (This is slightl unusual, as José's digita from a different manufa First the contrast was a through curves (2), with input set at 37 and outp to 60. Next, colour bala was adjusted, including tweaking of brightness a

3 colour balance

4 unsharp mas

> 4Mp digital compact
> TIFF
> Photoshop
> Breezebrowser plug-in
> Nikon Capture
> curves
> colour balance
> brightness/contrast
> unsharp mask
> noise reduction
> silver halide prints

48 digital basics

section title

shoot – enhance – enjoy

Each spread is divided into the sections 'shoot', 'enhance' and 'enjoy'. 'Shoot' explains the background details up until the moment of capture. The choice of equipment and the context of the shoot are revealed. The 'enhance' section explains the process that the image has been through once in computer, outlining the stunning results that the digital photographer can create post-capture. The 'enjoy' section reveals how the image has been used for personal enjoyment or professional use.

tips

Practical tips from the author and photographer allow the reader to apply issues raised in the images discussed to their own creative work.

images

The images in this book feature popular close-up subjects. We also showcase the ever-expanding genre of 'conceptual' images. All these types of subject matter have their place in modern image-making and, from the traditional to the surreal, there are examples of images for people of all tastes to appreciate.

digital compact camera fitted with a +10 and a +7 dioptre lens, which enabled an even shorter working distance, and hence greater magnification. Two flashes – one either side of the camera – mounted on a rigid support, provided even illumination. However, these were not used with auto or TTL (through the lens) flash modes,

but were manually balanced. The camera's manual exposure mode was set, and a TIFF file created from the captured image. The shot was taken after a rain shower. José likes the clean atmosphere this creates, as well as the resulting purity of colours. In addition, drops of water added energy to the scene.

! **Search for the best daylight and enrich it with flash, reflectors and diffusers before using the computer to make subtle enhancements.**

enjoy

José creates images for his own pleasure, and for family and friends. Some are exhibited at a local public tavern. His best shots are usually printed at 20x30cm, or 13x18cm, and output on to silver halide paper.

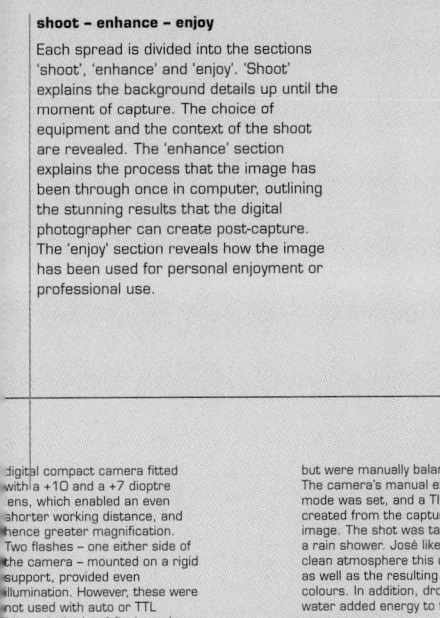

contrast to values of +5 and +11 respectively, with colours set at red (–3), green (+13) and blue (–8).

Unsharp mask settings of 10%, 3% and 1% were introduced to sharpen the image (4). Finally, noise was too pronounced for José, so was corrected with a reduction value of 3.

1/ The original capture.
2/ Modification of the contrast.
3/ Colour changes.
4/ Application of unsharp mask.
5/ The final image.

captions

The image captions clarify and recap the processes shown in each image.

spread title

1 the digital mind-set

'Rust' by Lou Verruto.

Using a professional digital SLR with roughly 6Mp in capture, this image was taken at the Great Pumpkin Farm in Clarence, New York. What attracted Lou Verruto to the scene were the contrasting elements of an old rusted truck and the autumnal colours of the flowers. Just five minutes were spent working in Photoshop, using adjustment layers, along with levels, curves, hue/saturation, gaussian blur and lighting effects to work the image into the eye-catching result shown here.

in this chapter...

This chapter looks at
different approaches to
close-up and macro
photography, and their
correct definitions. It also
provides an overview of
ideas and styles as a taster
of what is to follow in later
chapters.

definitions I

Describing close-up, macro
and micro photography
can be confusing. Here
we look at a true macro
image, combining not just
the photographer's vision
in seeing the 'shot' at the
onset, but then ways to
manipulate first the
camera, then post-capture
software to arrive at a
successful result.

pages 14–15

definitions II

The term close up is often
used to describe an image
that, technically at least,
is not a true close up.
However, so widespread
is this approach that we
include a few which use
this play on words in this
book. Here the crop tool
is used to fundamental
effect.

pages 16–17

definitions III

The best optic for close-
up and macro
photography is a macro
lens, which offers
exceptional resolution.
Here, such resolution
was put to good use later
on when the image was
severely cropped during
post-production.

pages 18–19

first moves

This section deals with the common first touches of post-production, such as brightness/contrast adjustments, colour enhancement and hue/saturation control, demonstrating a simple yet rewarding approach.

pages 20–21

seeing it through

Where an original capture is far from ideal, major improvements can be made through simple procedures such as adjusting levels and curves, and cropping. Here, household lighting creates a simple yet striking image.

pages 22–23

plug-in and power up

Plug-in filters enhance many software programs. They are the cutting edge of artistic effects and provide, at the very least, an automated way of introducing a particular effect. For many they are an invaluable part of the workflow.

pages 24–25

compact quality

Digital compact cameras are usually sufficient for close-up photography, with small sensors, zoom lenses and high optical quality for focusing close-up. As a result, the image in this section required minimal post-production work.

pages 26–27

serious kit

At the other end of the scale, those dedicated to close-up and macro photography use an SLR and associated accessories. Of these, the macro lens is a must. However, top kit does not automatically produce great images.

pages 28–29

! Low angles can add real impact to many close-up subjects.

! Flash is another aid to freezing the subject sharply. Ring flashes or twin-head macro flashes are often beneficial for some subjects. These also enable a stopped-down aperture for increasing depth of field effects.

definitions I

The term 'close-up' can be misleading, being wrongly interpreted as it often is to mean a shot taken with a telephoto lens from some distance away where the subject is still tightly framed. Though common sense to some degree supports this interpretation, in reality in the world of photography it is incorrect. However, so widespread is this misconception that we have included here various examples that fit differing definitions.

Technically, a close-up shot is defined by the magnification of its subject. This is a mathematical formula comparing its real (life) size with the size at which it is reproduced on a camera's sensor or film. By definition, close-up images are shot just that – close-up – with a relatively short distance between lens and subject. Unfortunately, camera and lens manufacturers sometimes mislead with the way they describe their products. Probably the easiest place to start is with the term 'macro'.

Macro photography is taken with equipment that enables a magnification or reproduction ratio of between lifesize (1:1) and ten times lifesize (10:1). The fraction is always written with the ratio first and the subject size second: 1:1 means both are the same, while 10:1 means that the reproduction is to a scale, making the image size on the sensor or film ten times the size of the actual subject. If the figures were written the opposite way around, for example 1:10, this would mean that the reproduction ratio, or magnification size on the sensor or film, would be one-tenth that of the actual subject.

This can all get a bit confusing, but if you are involved in more technical types of photography you will appreciate the importance of knowing what the magnification is, and how to change it with various types of equipment. The generally accepted definitions for each type of photography are that between one-tenth lifesize (1:10) and lifesize (1:1), we are talking about close-up; going beyond 1:1 we enter macro photography. At 10:1 or greater we are dealing with micro photography. However, it can take time for these definitions to sink in, and to confuse things further, add-on accessories can enable equipment to be classified in more than one way, depending on total magnification with or without the accessories.

shoot

Michigan-based Heather McFarland, an enthusiast with an eye towards digital photography as a second career, created 'Dandelion Blues' with a pro-digital SLR with a 6Mp resolution, which could be interpolated for its RAW files up to 10Mp. It was fitted with a 60mm micro lens, although the magnification only becomes micro with accessories. On its own it has a maximum 1:1 reproduction ratio, making it a macro optic. Whilst looking for

1

> 6Mp digital SLR
> RAW
> white balance
> contrast adjustment
> TIFF
> inkjet print

Checked out item summary for
BORRIA PABLO GUSTAVO
11-23-2010 10:21AM

BARCODE: 33477454117434 **737.403M153**
LOCATION: fmeyw
TITLE: the world encyclopedia of coins &
DUE DATE: 12-16-2010 CLMS RETD

BARCODE: 33477003826298
LOCATION: infcw
TITLE: National Geographic photography f
DUE DATE: 12-06-2010

BARCODE: 33477003178732
LOCATION: infcw
TITLE: The making of great photographs :
DUE DATE: 12-06-2010

BARCODE: R0114007954
LOCATION: hcarw
TITLE: The Tao of photography : seeing b
DUE DATE: 12-06-2010

2

enhance

enjoy

macro images to shoot in a local park, Heather spotted this beautiful large dandelion. Capturing a unique angle and look, the camera was placed on the ground, shooting upwards into the dandelion from beneath. Aperture priority exposure mode was used, giving 1/125sec shutter speed with an f/5.6 aperture and ISO 250 sensitivity. The white balance was also set to achieve this cloudy look, with a –3 increase in colour temperature to get the blue tint that resulted from the dandelion being in deep shadows.

About an hour was spent tidying up the image with basic enhancements such as increasing the contrast. Heather mostly uses Corel Photo-Paint, but also Photoshop and MacBibble software. The image was then saved as a TIFF file.

Heather makes prints for her own enjoyment, and this one hangs at home. She also sells them online via her website and to a number of fine-art dealers around Michigan state.

1/ The original image was a macro shot taken from a stunning angle.

2/ The final image.

! Nearly all macro shots will need a tripod or other support. Why not use a camera's mirror lock-up or self-timer to reduce movement even further.

'Close-up photography is amazing, for you can see the world very differently.'

definitions II

The way we use images is changing as well as increasing. Trying to get as much right as possible in-camera helps by simplifying the rest of the image-making process. If you shoot for Internet use, then you can reduce the capture resolution and get more images on to a memory card. However, as was the case here, having more resolution at the outset can be of benefit if the image is to later be used for other purposes, such as its reproduction in this book.

shoot

Tarence Wong is a digital photography enthusiast. This image was captured on a digital compact with an add-on teleconverter. Technically it was not captured as a close-up but, in one sense, this is what it became.

! Never use any sharpening prior to enlargement by interpolation, as this can cause the effects of the sharpening process on edges to become obvious.

enhance

The original shot was opened in Photoshop and the picture cropped for better composition and framing. Curves were then modified and the unsharp mask filter applied.

enjoy

Tarence does not usually make prints. Instead, he views his images on computer, and stores them on the Internet. If you were to frame this image, what colours would you use? One approach might be to add a border using canvas size [Image > Adjustments > Canvas Size]. [2]

2 canvas size

Current Size: 9.19M
Width: 77.19 cm
Height: 51.79 cm

OK
Cancel

New Size: 9.49M
Width: 1 cm
Height: 1 cm
☑ Relative
Anchor:

Canvas extension color: Other...

> 6Mp digital compact
> Photoshop
> crop
> curves
> unsharp mask
> Internet

1/ The original capture.

2/ A simple touch to get an idea for a frame or matt colour that might be suitable for a particular image is to use canvas size and place a border of colour around the image onscreen.

3/ The final image.

! Look post-capture to see if any parts of an image are superfluous to its impact.

definitions III

A macro lens is a good choice of optic – a good all-rounder. It not only focuses close up, but also at greater distances, so you can get macro, close up and subjects all the way up to infinity focus.

shoot

'Nature's Pearls' is another of Heather McFarland's images. More macro than close up, it was captured with a 60mm macro lens on her pro-digital SLR, which was tripod mounted. 'I have a large field of wild flowers and plants behind my home. There are many spiders that make their home in the plants there. One dewy morning in August, I went in search of spiders' webs with dew draped all over them. This image is the result of that search.'

1/ The original image was a little untidy.

2/ Images within images: using the crop tool produced a more eye-catching result.

3/ A curves adjustment reworked the tonal distribution.

4/ The final image, beautifully reworked.

> 6Mp digital SLR
> Corel Photo-Paint
> crop
> contrast/brightness
> curves
> inkjet print

enhance

The original image had potential without an overly complicated post-production workflow. It required only tidying up and enhancement.

First it was cropped using Corel Photo-Paint (2). Common to most digital images, contrast and brightness needed adjustment, in this instance using curves (3).

enjoy

Several prints of this image in 12x8 inch and 16x11 inch sizes have been produced using an inkjet printer.

> 'With digital you can try several settings before you get the right exposure and composition – you see your work as it happens.'

the difference between an image being nearly there and being absolutely right, here an even further increase to the contrast was made [Image > Adjustments > Brightness/Contrast] [4]. The brightness level remained set at 0, with contrast increased to a value of 15. From beginning to end, Miguel spent around 45 minutes adjusting the image.

first moves

While we all work differently, depending on our subject and style, at the outset of most post-production there are often a number of recurring themes. This section looks at a typical example of where you may want to begin.

shoot

Miguel Lasa, based in Hartlepool, England, captured this simple but effective image with a 6Mp digital SLR. The 28–200mm general-purpose zoom lens was set for a focal length of 90mm. Using 100 ISO sensitivity, the exposure was made at a shutter speed of 1/6sec with an f/22 aperture, as directed by the camera's multipattern meter. The image was captured as a JPEG file.

The image was taken in Durham Botanical Gardens. For Miguel, the patterns on this big leaf resembled an aerial view of the network of streets of a town. The camera was placed underneath the leaf for the most effective composition and backlighting, helping to bring out the detail.

enhance

Working in Photoshop, Miguel began by tweaking the hue and saturation [Image > Adjustments > Hue/Saturation]. Values were set to 04 (Hue), 34 (Saturation) and –16 (Lightness) [2]. The degree of specific pixel brightnesses was then altered [Image > Adjustments > Levels]. Here, values of 0, 1 and 235 were set, as seen on the histogram [3], forcing more of the lighter pixels to become even lighter. Though not visible here, onscreen this increased contrast resulted in a subtle change, giving the perception of increased sharpness. Though small changes such as this can mean

3 levels

2 hue/saturation

> 6Mp digital SLR
> JPEG
> Photoshop
> hue/saturation
> levels
> brightness/contrast
> Internet printing
> frame

**'Use the computer
to improve your
pictures digitally.'**

enjoy

Miguel utilises an Internet
printing service, and in this
instance the resulting 12x8 inch
print is now housed in a black
frame surround.

1/ The original capture.

2/ Hue adjusts the shade of a particular
colour range, while saturation intensifies
or lessens its purity by adjusting the
amount of diffusion. For 'lightness' we can
read 'brightness' to understand the effect.

3/ The histogram, either in-camera or
opened in your post-production program,
is a simple way to see how the range of
pixels are distributed in relation to
brightness. Here, the number of pixels
reaching maximum brightness has been
increased.

4/ Brightness and contrast almost always
need adjusting.

5/ The final image.

4 brightness/contrast

Brightness: 0

Contrast: 15

OK
Cancel
☑ Preview

5

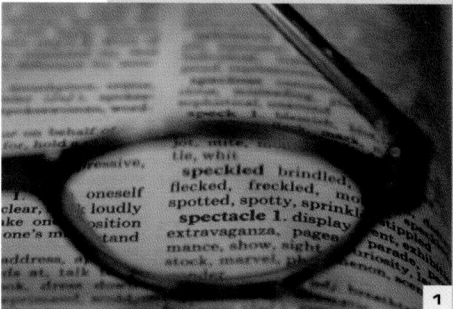

1

! A tripod-mounted camera is not
only an aid to stable shooting
and the setting of the exact focus
point, but also allows minute yet
often crucial adjustments to be
made easily.

seeing it through

Combining simple steps,
each designed for a
specific effect, even far-
from-ideal originals can be
transformed into images
of impact. Like many good
close-up images, 'Seeing
Clearly' was created with
subjects close at hand,
and under the
controllable conditions
found at home. It is a
good example of what can
be achieved with sensible
manipulation post-
capture.

> 6Mp digital SLR
> JPEG
> Photoshop
> crop
> curves
> brightness/contrast
> auto colour
> magic wand
> levels
> unsharp mask
> inkjet print

shoot

Simon Wootton used a 6Mp
digital SLR fitted with a 100mm
f/2.8 aperture macro lens for
this shot. The APS size of the
sensor in the camera made this
an effective equivalent of a
160mm lens on a full-frame
model. Illuminated by two bright
household lamps, metering was
set for multipattern assessment.
Even though the image was shot
at 1/500sec shutter speed, with
f/5.6 aperture and 100 ISO
sensitivity using aperture priority
exposure, a tripod and a cable
release were still used – often a
fundamental requisite of any high-
quality close-up shot.

Edinburgh-based Simon is honest
enough to admit that, at capture,
he never quite got the colour
balance right. As he was not
shooting in RAW file format at
the time, this limited his post-
capture options, necessitating
more post-processing than he
would have liked.

enhance

Photoshop was used to
manipulate the image. Simon
started by cropping slightly,
before attempting to add some
contrast using curves [Image >
Adjustments > Curves] (2). This
required further tweaking, via the
brightness/contrast slider [Image
> Adjustments > Brightness/
Contrast] (3). The auto colour
Balance function was used next
[Image > Adjustments > Auto
Colour]. And, finally, the word

3 **brightness/contrast**

Brightness:	0	OK
Contrast:	8	Cancel
		☑ Preview

2 **curves**

Channel: RGB

OK
Cancel
Load...
Save...
Smooth
Auto
Options...

Input: 73
Output: 55

☑ Preview

4 **levels**

spectacle 1

Channel: RGB
Input Levels: 29 0.70 255

OK
Cancel
Load...
Save...
Auto
Options...

Output Levels: 0 255

☑ Preview

'spectacle' was selected using the
magic wand tool with a tolerance
of 75, and then darkened with
levels [Image > Adjustments >
Levels] (4). A little unsharp mask
was then applied, but only to the
selected word (5). As is often the
case, here 'less is more', with
small adjustments such as these
just nudging an image up a level.

6

enjoy

Simon prints for his own enjoyment and would normally make an 8x6 inch print at 300dpi of images like this one on his inkjet printer.

1/ The original capture.

2/ Adjusting curves to increase contrast.

3/ Further manual adjustment of contrast.

4/ Levels was used for selective contrast modification.

5/ Unsharp mask provided the final touch.

6/ The final image.

5 unsharp mask

OK
Cancel
☑ Preview

— 200% +

Amount: 101 %

Radius: 2.0 pixels

Threshold: 3 levels

'I've always been a fan of experimenting and trying something new, and macro/close-up photography can breathe new life into old subjects. Doing it digitally has the benefits of preview, and cost-effective trial and error.'

! Experiment and try anything once, then try it again!

1

plug-in and power up

Plug-in filters can make images captured by amateur photographers look like they have been created by a professional artist. The filters extend the capabilities of host programs such as Photoshop by creating extra effects in an automated way, offering a simple route to striking results.

> 5Mp advanced digital camera
> JPEG
> Photoshop
> auto levels
> auto contrast
> saturation
> clone
> crop
> inverse
> zoom
> lasso
> magic wand
> plug-in filter
> clone
> brightness/contrast
> hue/saturation
> unsharp mask
> inkjet print

shoot

For 'Blue Eyes', Ray Philson, who describes himself as an amateur, used a 5Mp advanced digital camera to capture the initial shot. An SLR, this featured a fixed zoom lens equal to a 28–210mm lens on a full-frame camera. Using 100 ISO sensitivity, the aperture selected by the program mode was f/4.

The shot was taken at a friend's house in the weeks leading up to her wedding, just after she had visited a beautician for a practice make-up session in preparation for the big day. Ray, from Bristol, England, had always wanted to take a shot like this – similar to others he had seen – so the timing was perfect.

! If you spot the potential of an image of a particular person, ask him or her whether you can take the shot. They can only say no, and may even be flattered.

enhance

Post-production using Photoshop took around two hours. Ray first selected auto levels, followed by an auto contrast adjustment [Image > Adjustments > Auto Levels > Image Adjustment > Auto Contrast]. However, because the initial exposure was good capturing an excellent range of pixel brightness levels, both bright and dark this had little effect on the image. Phil therefore decided to increase saturation to 25%, lifting what he considered was still a flat image, to give it more 'zap' [Image > Adjustments > Hue/Saturation] (2).

Ray spent a lot of time cloning his reflection out of the eye, as his own hands as well as the camera lens were still visible in the shot. Stray eyelashes were also removed, to get rid of the clumps of make-up so visible in such a high-resolution image. Cropping tighter, Ray then manually

selected the iris, inversing it in order to make the rest of the eye the active area [Select > Inverse]. This was done with a combination of the lasso and magic wand tools after zooming into the picture at 500% magnification, which helped to identify errant pixels. Ray turned off anti-aliasing and lowered the feather on the lasso tool from its default, whilst increasing the tolerance on the magic wand. Though the selection was made here using a mouse, a graphics tablet usually makes life a little easier.

A plug-in infrared filter from Photoeffex was applied next to the rest of the image. This removed much of the detail, leaving a bright, high-contrast monochrome effect yet retaining the important areas of detail. Further time was spent cloning, removing errant lines and dots resulting from the effects of the filter. Brightness was increased a

2 hue/saturation

Edit:	Master		
Hue:	0		OK
Saturation:	25		Cancel
Lightness:	0		Load...
			Save...

☐ Colorize
☑ Preview

3

further 20%, creating an overexposed look. Ray reselected the iris, increasing the saturation, and finally ran unsharp mask across it [Filter > Sharpen > Unsharp Mask].

1/ The original capture.

2/ Hue/saturation was adjusted in Photoshop to enhance the colours.

3/ The final image.

Ray creates images mostly for his own enjoyment, however his work has also appeared in local exhibitions. An 8x10 inch print of 'Blue Eyes' on inkjet paper was placed in a silver-edged glass frame as a wedding present.

'The images are tack sharp, and often picked up details I hadn't even noticed with the naked eye.'

1

compact quality

Digital compact cameras have an advantage in that the sensor size is small. With pixels packed into this area, the inherent resolution is high compared with a large sensor with the same number of pixels, and by their nature the pixels will be larger and have less resolution as a consequence. Combined with small sensors and apertures, this allows for a large depth of field, usually crucial for close-up photography.

2 exif data

DSCN2618.jpg

Description	Camera Data 1
Camera Data 1	
Camera Data 2	
Categories	Make: NIKON
History	Model: E4500
Origin	Date Time: 2003-07-03T15:46:32+01:00
Advanced	
	Shutter Speed:
	Exposure Program: Aperture priority
	F-Stop: f/7.7
	Aperture Value:
	Max Aperture Value: f/2.6
	ISO Speed Ratings: 100
	Focal Length: 19.1 mm
	Lens:
	Flash: Did not fire
	No strobe return detection (0)
	Compulsory flash suppression (2)
	Flash function present
	No red-eye reduction
	Metering Mode: Pattern

Powered By
xmp

Cancel OK

enhance

Photoshop was used post-capture. However, the captured image, straight out of the camera, was virtually what Mary-Ella wanted. No cropping was therefore necessary, though a few blemishes on the leaves were cloned out using the clone tool, with minimal levels adjustment. The final touch was to use the unsharp mask filter [Filter > Sharpen > Unsharp Mask].

shoot

'Urban Jungle' was captured using a 5Mp digital compact camera in the summer, among hosta plants in the photographer's garden. California-based Mary-Ella Keith has always been intrigued by the effects of light as it passes through translucent leaves or flowers. This, she finds, can be quite beautiful. Mary-Ella was confident this subject would lead to a good image due to the graceful contours and lines of the leaves' veins.

As with any subject, finding the best angle to shoot from can make or break an image. Adding

a different twist, Mary-Ella shot the image from ground level, looking upwards to achieve a strong 'monumental' look from this common garden plant.

Here, the swivel-body design of the compact was particularly helpful, placed on the ground with the lens aimed upwards into the underside of the leaves. The camera was set to its macro mode with a shutter speed of 1/45sec, and an aperture of f/7.7. The zoom lens was set to a focal length of 19mm, and sensitivity to ISO 100. The file was captured as a JPEG.

1/ The shooting angle resulted in a powerful composition.

2/ Photoshop's Exchange Information Format [Exif] data [File > File Info > Camera Data 1] tells some of the story of the capture details.

3/ The final image.

> 5Mp digital SLR
> JPEG
> Photoshop
> clone
> levels
> unsharp mask
> inkjet print
> TIFF

'Try to take some photos every day. It won't be long before you start to spot photo opportunities wherever you look.'

enjoy

Mary-Ella makes prints for her own enjoyment, and for family and friends. Some make their way into exhibitions. Customers for her work include corporate clients and private collections. 'Urban Jungle' was output in several sizes of inkjet print, the largest being 8x10 inch. In general, her preference is for very simple, elegant-looking matts and frames. Typically white or slightly off-white matts are placed within black wooden frames. For the image reproduced here, Mary-Ella supplied an 11Mb TIFF file.

3

1

serious kit

It is vital to pay close attention to the details of a subject, as close ups can reveal minor blemishes or imperfections. Though the purist may suggest leaving blemishes in, it is still important to show a subject at its finest, which entails cloning out or touching up any imperfections to the degree that they do not detract from the beauty of the image.

shoot

'Lotus', by Heather McFarland, was captured using a 6Mp SLR with a 60mm macro lens. Heather likes digital capture for its immediate feedback from the LCD display, 'something invaluable in determining if you are on the right track with your f-stop and shutter speed for close-up work'. It also helps ensure you 'get the shot' and are not disappointed. The image was captured in her garden one April, as the first of the spring flowers were beginning to appear. Heather was aiming for a softly focused image of one of the flowers, making its yellow centre the point of focus. An f-stop small enough to accommodate this was required, but one not so small that it would create too much depth of field. The solution was an exposure of 1/640sec at f/5.6, using aperture priority exposure mode, with a small decrease in exposure of EV –0.3. This helped saturate the colours and avoid burning out too much highlight detail, which is particularly important with digital capture. The ISO was set to the camera's lowest 125 rating.

enhance

Heather usually uses Corel Photo-Paint editing software, as well as Adobe Photoshop and MacBibble, the latter for RAW file conversion. Added to this arsenal are a host of filters, plug-ins and Photoshop tools. Attention to detail here was intense, taking around four hours to carry out the work. Apart from cropping and retouching (2/3), there was also a tone curve adjustment over the entire image to lighten it up a little (4), followed by cropping to the composition required. The image was also flipped horizontally for effect.

> 6Mp digital SLR
> exposure compensation
> macro lens
> RAW file
> MacBibble
> TIFF
> crop
> touch up
> tone curve
> flip horizontally
> inkjet print
> silver halide print

2 crop

3 touch-up tool

1/ The original was taken in Heather's garden, but she could not get as close as she would have liked because the flower was growing in the middle of a small pond.

4 **tone curve**

Channel: RGB Channels

Curve Style:

Null Balance Options...

aug01191

☐ Display All X: Y:

Preview Reset OK Cancel Help

5

enjoy

Prints are made for Heather's own enjoyment and to sell from her website. A few prints are sold to fine-art dealers in Michigan state. 11x16 inch and 16x24 inch inkjet prints have been produced, as have silver halide images from a Durst Lambda printer. Prints are sold framed, or unmounted so that buyers can choose frames to match their decor and to suit their personal tastes.

2/ 3/ The image was later cropped to the size required and the touch-up tool was used to eliminate some of the pollen and other distracting spots on the petals.

4/ An adjustment curve was also applied.

5/ The final image.

! Even non-macro lenses can make great optics for 3D subjects. A trick of the trade for many professionals is to use an extension tube between the camera and a long telephoto lens such as a 300mm. Telephoto lenses such as this are usually constructed in a high-quality apochromatic glass design. By themselves they are unable to focus particularly close, but adding one or more extension tube greatly reduces the closest focus point, in many instances creating a top-quality macro lens with a wonderful working distance.

6/ The initial exposure for 'Soft Colors of Spring', also by Heather McFarland, was underexposed slightly by –0.3 EV. This kept highlight details without burning them out, helping to keep the quality captured at the outset high, demonstrating that it never pays to skip on attention to detail at the beginning, as this simply makes for more work later on.

7/ The final image.

6

7

macro lenses

Although a digital compact camera can be very good for close-up work, especially with add-on close-up lenses, nothing equals an interchangeable lens SLR. Manual focus is still the best method of control for many subjects, particularly as the magnification increases. A macro lens is the ultimate in close-up quality, especially for photographing flat copy such as technical drawings or maps, as it is designed to give a 'flat field' with even sharpness from edge to edge. (Non-macro lenses are not capable of doing this to such a degree, as they are not designed to be used as flat-copy optics.) The longer the focal length, the greater the working distance with macro lenses, something which again can be important depending on the lighting and subject. Macro lenses come with different focal lengths for this reason, but often with a similar, if not identical, maximum magnification.

accessories

When moving from close-up to macro work, then to micro work, for example, you may need a higher magnification than a macro lens alone can provide. In this case, you may find a bellows system an advantage. An accessory for the dedicated photographer, a bellows system allows easier adjustment when working with the very shallow depth of field found at such magnifications.

8/ For close-up, but especially for macro and micro photography, a bellows system makes life simpler, either for working at a set magnification or for focusing precision. Likewise, close-up supplementary lenses or extension tubes are also essential items to increase maximum magnification ratio beyond what is possible with a lens alone.

8

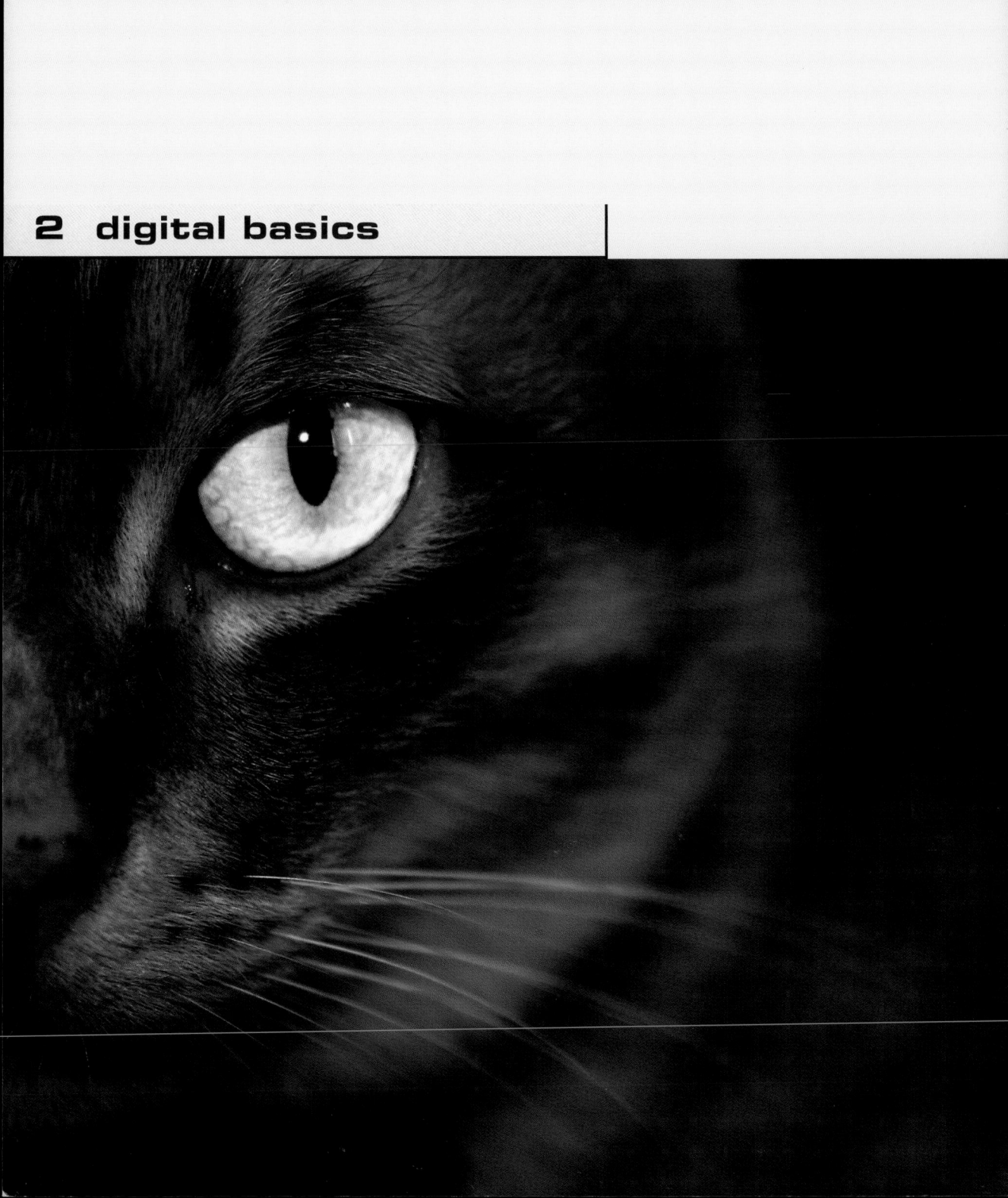

2 digital basics

'Cat's Eye' by Tarence Wong.

Hong Kong-based Tarence captured this image using a professional 6Mp camera fitted with a 180mm f/2.8 macro lens. The lens features apochromatic glass, which is desirable for digital capture on professional cameras. Slightly cropped using Photoshop, the whole image, except for the eye, was then selected and desaturated. Curves then achieved the desired contrast. Next the eye was selected and saturation increased to make it pronounced. The image was finally sharpened using the unsharp mask tool.

in this chapter...

Outlining the basics of
digital imaging post-
capture, this chapter
features various examples
where these small
adjustments can make a
big difference.

starting position

This section considers
various in-camera
controls, demonstrating
why it pays to think this
stage through with care
to minimise time spent
post-capture. We then
champion levels, a basic
but flexible post-capture
adjustment.

pages 36–39

close-up crop

A more detailed look at
the crop tool, the
adjustment of which to
suit images onscreen
and for printing is
perhaps underutilised.
The section includes a
simple but striking
composition created
using this tool.

pages 40–43

simple life

Why complicate things?
Start with a considered
composition to make
your work easier and
more enjoyable. Tonal
adjustments plus soft-
focus effects from a
plug-in were all that was
necessary to wrap up
the image in this section.

pages 44–45

natural look I

Just because we *can* make things look surreal, does not mean we should. A considerable amount of close-up and macro photography actually benefits from a conventional and natural look.

pages 46–47

natural look II

Noise can destroy an image. Here, we consider how the effects of noise may be reduced, at the same time looking at a high magnification image taken with the aid of extension tubes – one of the most useful items for macro photographers.

pages 48–49

play on words

This section explores the flexible Variations option in Photoshop. The image here also demonstrates the benefits of taking your time when capturing an image – choosing the moment and steadying the camera as much as possible.

pages 50–53

anytime, anywhere

Close-up and macro photography is not easy to do well, but can be done almost anywhere. This example used household lighting, but gives the impression of more complex illumination due to the photographer's skills post-capture.

pages 54–55

'In addition to the camera, memory cards, lenses, a reasonably fast computer, and a good monitor and printer are as essential as a tripod for digital photography.'

! A calibrated monitor is a must for good digital imaging. Calibration should be carried out regularly, for example once a month, using supplied software or, even better, using a spyder to measure the monitor's physical response to colour.

starting position

Considering some of the wealth of available options, either packed into a digital camera or camera back, at the outset, in order to simplify the workflow later on, is a basic principle of good digital photography. No single solution is ideal for all situations, but it's a waste not to mould your camera and any accessories you buy into a specific tool. The easiest post-production starts with a good image, the basic characteristics of which do not need modifying.

shoot

Good exposure is vital to producing a decent digital image, and cameras now have more options available to determine and execute this than ever before. It is particularly important to avoid overexposure, as details lost at the outset cannot be recovered later on. It is sensible to experiment with your camera's metering methods, and often a good idea to bracket exposures, particularly if creating JPEG or TIFF files in-camera. Though there is more flexibility to adjust RAW files post-capture, this can be time-consuming if you are working on many images at a time.

Most models now have facilities which let you control and change the colour characteristics of an image, so why not use these? And there's often a selection of image 'looks' to choose from, including ways to lower or increase the saturation, or adjust the hue, and even to 'optimise' for specific subjects such as people or nature. Some cameras also enable tone curve adjustment of the contrast of an image.

Another important decision to make at the start is based on

Useful stages for getting the best image out of camera

> exposure

> bracketed exposure

> **RAW file**

> **JPEG/TIFF**

> colour characteristics

> hue/saturation

> tone curve

> in-camera sharpening

> image comment

1 | **exif data**

	Camera Data 1
Description	
Camera Data 1	Make: NIKON CORPORATION
Camera Data 2	Model: NIKON D1X
Categories	Date Time: 2001-08-10T14:17:21+01:00
History	Shutter Speed:
Origin	Exposure Program: Aperture priority
Advanced	F-Stop: f/5.6
	Aperture Value:
	Max Aperture Value: f/2.8
	ISO Speed Ratings:
	Focal Length: 28.0 mm
	Lens:
	Flash:

Powered By
XMP

Metering Mode: Pattern

(Cancel) (OK)

the setting for in-camera sharpening. The default level for this on most cameras is usually moderate in strength, with settings from 'none' to 'high'. The first is best if you are making very large prints, or having work reproduced in a magazine or book. The latter

may be used if images are to be placed on the Internet, while the levels in between typically suit moderate print sizes and a host of other uses. It is difficult to give hard and fast rules to suit preferences, image type or reproduction size, so why not experiment?

1/ Exchange Information Format (Exif) data can help guide you if things go wrong or you want to judge differences between shots. Cameras write this information within the file as part of its 'meta' data. Various programs can read this. In the latest version of Photoshop, some of the information is accessed via File > File Info > Camera Data 1.

2/ Piotr Lorenc is a professional photographer from Poland. Here, getting the settings right for 'Wet' in-camera saved time post-capture. Little was done to this image in Photoshop. In fact, good exposure and other considerations made for a post-production time of only around a minute.

enhance

Choosing the best file type will be covered later on, however, a number of advanced cameras enable you to create images with more or less colour data – called 'bits'. In principle, the greater the bit 'depth', the better the colour reproduction should be. For a recognisable image of photographic quality, 8-bit data at each pixel for red, green and blue is necessary. If you take 2-bit data you get one black, one white; 4 bit is one black, one white and two grey. When you get up to 8 bits you end up with 256 shades of red, 256 shades of green, and 256 shades of blue in an RGB image. When combined (256 x 256 x 256) we get what we refer to as a theoretical 24-bit image or, put another way, more than 16.7 million colours. Some cameras are able to capture more, as can a film scanned using a higher bit depth. This also depends on the file format chosen. But is it worth it?

Image application programs such as Photoshop can deal with 16-bit images per channel (16 x 16 x 16), however, some features only work with 8-bit data (24-bit), as do many other programs. The benefit if everything falls into place is that when sampling the data recorded and deciding on different shades and tones, even when reducing this down to an 8-bit image, the greater captured detail makes things more accurate, especially in parts of the image with delicate tonal separation. The down side is that this can be time-consuming and file sizes increase substantially. As a guide, if you are having work published or sold as stock, it can be worth the extra effort, especially if dealing with delicate hues and/or highlight/shadow details. But if outputting for prints, it is usually enough to stick with 8-bit capture.

levels

The distribution of brightness values can be viewed on the histogram in the levels dialogue box [Image > Adjustments > Levels]. On the left are black pixels (0), while 256 levels brighter are the white pixels (value 255). Each has an adjustment triangle below it. Sliding these forces more pixels to become black or white, and hence increases contrast, making more grey values one way or the other. The third, mid triangle represents a mid-grey tone, and starts with a value of 1, which represents the normal gamma. Reset to a new value, a change above a gamma of 1 brightens the mid-tones but not the extremes.

Another, lesser used control is that of output. This allows the 256 range of brightness to be reduced or 'clipped' to a smaller value, reducing the contrast of an image since there will be no black or white brightness levels. This is useful if an image is very high in contrast and you need to maximise mid-tone detail.

3/ The original image, 'Grater' by Patrick Campbell, was converted to a 16-bit TIFF file in Photoshop.

enjoy

Although they have a default setting, most digital cameras enable different colour spaces to be used when creating an image. Available options include sRGB in various forms, or Adobe RGB (1998), which are usually found in the menus. As a rough guide, if images are to be viewed only onscreen, for example on the internet, the

first is preferable. However, if work is to be reproduced in books or magazines the second is better.

Other options to consider could include adding an image comment if your camera allows this. This could take the form of text saying a little about the shot, which is especially useful if the file is to be handed over to

another person quickly. It can also act as an *aide memoir* to yourself. The information is stored within a small part of the file called the 'meta data', and can be retrieved with a suitable software program.

Taking things a step further, some models also now enable audio recordings to be made.

4/ California-based Patrick took this image as an assignment for a stock-photography class. The assignment was to produce close-ups of kitchen items. A shiny new grater was set up outside on the back porch on a grey day in winter. Using a medium-blue art paper for the background, the image was captured with a 6Mp SLR and 105mm macro lens. Post-capture, the clone tool was used to remove two tiny reflections in the middle row of the grater holes. Using levels, the black-and-white points were set to the left and right edges of the histogram and the neutral grey point to a slightly brighter setting. Saturation was then increased to 40%.

! If you are not sure how you want the image to look, consider shooting **RAW** files. These can have the same, and sometimes more, settings applied to them in computer software as in-camera. Cameras that enable simultaneous creation of **JPEG** and **RAW** files are preferable. If necessary, you can revert to the latter as a digital negative.

4

> Shape, line and form are as relevant today as ever. To help create depth, use lines to lead the eye into or out from the subject.

1

close-up crop

One of the most useful tools and the simplest to use is the crop tool. No matter which software program you are using, this tool can dramatically change the impact of an image, or more subtly take the viewer where you want him or her to go. It can be worth experimenting to test the effects of this tool, to be sure you have the shot framed at its best.

shoot

'The Business End of a Cello' was one of around 25 shots taken by Ross Robinson one Christmas, while his son was back home during his final year of study at the University of Victoria in the USA. A keen amateur, Ross initially took it as a potential shot for a poster for the graduation recital.

Using a 6Mp SLR, fitted with a 28–105mm zoom, the exposure was made at f/5.6 with 1/40sec shutter speed, at the longest focal length. Combined with a 400 ISO sensitivity, this meant a tripod was unnecessary, and gave a shallow depth of field, which in turn helped give depth to the image, enhanced by the lines along the instrument. Maximum out-of-camera quality was achieved by using the TIFF file format, resulting in an 18Mb file size.

2

enhance

The image was taken into Photoshop Elements and cropped to remove highlights from the right side which were reflections from the sky (2). These added little to the image, however, by removing them the format became almost square. Though originally this was not what Ross had in mind, it was a compromise he was willing to make, as the resulting format also draws attention to the diagonal lines created by the strings and the bow. Note also the effect of the composition; the fingers stop the eye leaving the scene, therefore in some cases

> **6Mp digital SLR**
> TIFF
> **Photoshop Elements**
> crop
> brightness/contrast
> hue/saturation
> effects
> silver halide prints

4 hue/saturation

Edit: Master

Hue: -9
Saturation: 27
Lightness: 0

OK
Cancel
Help

☐ Colorize
☑ Preview

! An old adage for good photography is 'move closer'. During post-production, with the crop tool you can effectively do just that.

3 brightness/contrast

Brightness: 1
Contrast: 13

OK
Cancel
Help
☑ Preview

square can in fact be a good format choice.

Approximate adjustments of +1 and +13 respectively were then made to the brightness and contrast [Image > Adjustments > Brightness/Contrast] (3), then hue (-9) and saturation (+27) were adjusted [Enhance > Adjust Colour > Hue/Saturation] (4), almost completing the image (5). Then, from the effects options [Window > Effects], the frame was added using a near-neutral colour to avoid drawing attention away from the image (6).

5

1/ The original image was captured with a rectangular frame, but the shape needed to be changed for technical and aesthetic reasons.

2/ Reflections from the sky were cropped from the right side of the image.

3/ Brightness and contrast were tweaked.

4/ Hue and saturation changes were made.

5/ The nearly finished image.

6/ The frame effect was added as a finishing touch.

! Receding lines give depth to an image.

7

7/ The final image.

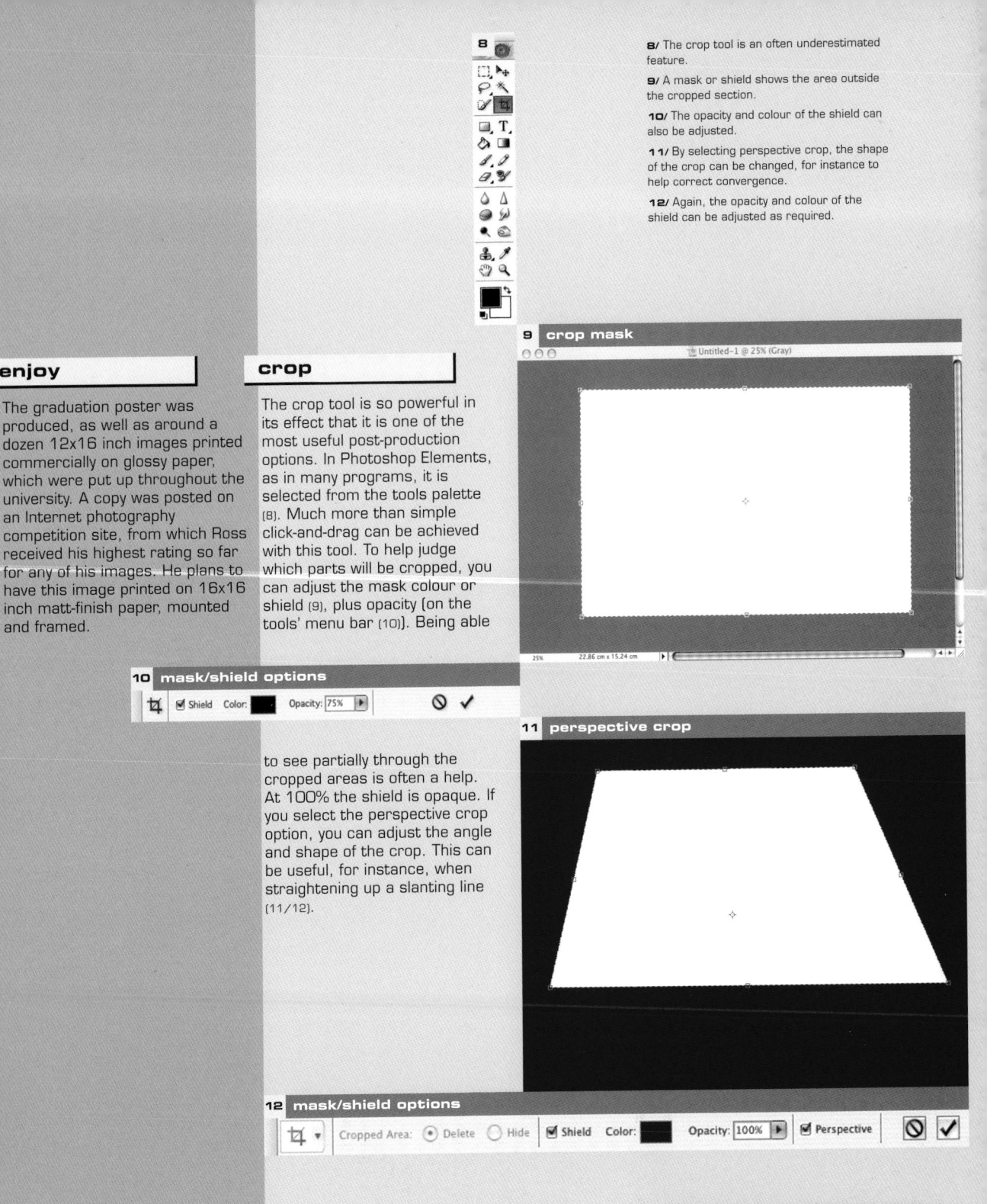

8/ The crop tool is an often underestimated feature.

9/ A mask or shield shows the area outside the cropped section.

10/ The opacity and colour of the shield can also be adjusted.

11/ By selecting perspective crop, the shape of the crop can be changed, for instance to help correct convergence.

12/ Again, the opacity and colour of the shield can be adjusted as required.

enjoy

The graduation poster was produced, as well as around a dozen 12x16 inch images printed commercially on glossy paper, which were put up throughout the university. A copy was posted on an Internet photography competition site, from which Ross received his highest rating so far for any of his images. He plans to have this image printed on 16x16 inch matt-finish paper, mounted and framed.

crop

The crop tool is so powerful in its effect that it is one of the most useful post-production options. In Photoshop Elements, as in many programs, it is selected from the tools palette (8). Much more than simple click-and-drag can be achieved with this tool. To help judge which parts will be cropped, you can adjust the mask colour or shield (9), plus opacity (on the tools' menu bar (10)). Being able

to see partially through the cropped areas is often a help. At 100% the shield is opaque. If you select the perspective crop option, you can adjust the angle and shape of the crop. This can be useful, for instance, when straightening up a slanting line (11/12).

9 crop mask

Untitled-1 @ 25% (Gray)

25% 22.86 cm x 15.24 cm

10 mask/shield options

Shield Color: Opacity: 75%

11 perspective crop

12 mask/shield options

Cropped Area: ● Delete ○ Hide ☑ Shield Color: Opacity: 100% ☑ Perspective

'Shoot as much as you can, and always keep your eyes open for an interesting shot, even if it does not fit the particular style of what you are shooting that day.'

simple life

Creating a good composition in the first place means minimal post-production work. Just because we have so many wonderful computer tools at our disposal, doesn't mean we have to use all of them. In fact, sometimes 'less is more', as the images here show. It's not just the enthusiast who benefits from simplicity; professionals also do not always have the luxury of limitless time for post-production work.

> 6Mp digital SLR
> Capture One
> RAW
> TIFF
> Photoshop CS
> curves
> Power Retouche plug-in
> QImage software
> inkjet print

1

4 soft filter

2

shoot

'The Grad Dress' was captured while Canada-based photography enthusiast Robert Ganz was shooting graduation photos at a local daycare centre. He was struck by this particular subject because of the way her hands were positioned, as well as the pretty dress. Robert decided to go for something different, capturing a full-frame shot of just the hands and dress with a 6Mp digital SLR fitted with a 100mm f/2.8 macro lens.

3 curves

Channel: RGB

Input: 205
Output: 214

enhance

Robert spent between 30 minutes and an hour on the image, just getting things right using his software. Initially the RAW file was converted to a TIFF file using Capture One software from Phase One. The following work was undertaken in Photoshop CS, and included a curves adjustment [Image > Adjustments > Curves] (3). A soft-focus effect was then applied via a Power Retouche plug-in filter (4), which even works on 16-bit TIFF files.

1/ The final image.

2/ The original capture.

3/ Contrast was adjusted via curves.

4/ Application of the plug-in soft filter.

enjoy

The image was produced as an 8x12 inch print using QImage software, however, Robert doesn't mount his images. He shoots for his own enjoyment, for contests, and some sales.

5

6

5/ 6/ This is another of Robert's shots, taken using a 100mm f/2.8 macro lens. 'I was walking around a golf course close to sunset, and noticed the low-angle light striking some seed pods.' The light illuminated the edges and Robert spotted the potential for a nice shot. Compositionally, though, it was lacking, so an interesting crop was made on the computer and the contrast was increased for impact. The image ended up not at all as Robert saw it while on his walk.

'Helicoverpa Armigera' was created by nature and photography enthusiast José Ramón Erezuma, who captured it at the Urdaibai (UNESCO) Biosphere Reserve in the Basque country in Spain. José has a fascination for those 'small beings who at first are not appreciated'. He used a digital compact camera fitted with a +10 and a +7 dioptre lens, which enabled an even shorter working distance, and hence greater magnification. Two flashes – one either side of the camera – mounted on a rigid support, provided even illumination. However, these were not used with auto or TTL (through the lens) flash modes,

natural look I

Much macro, like many other types of photography, is best represented by giving an image a natural look, where any post-capture enhancements are not obvious. This can be achieved with small steps and limited adjustment values; tools to create surreal or conceptual images do not necessarily provide the optimum solution. The image here achieves what the photographer was looking for by showing the colours and wonderful forms of nature in which he specialises.

'First of all, we must be respectful of nature; it is necessary to take care of it.'

enhance

Only a few minutes needed to be spent on post-capture work, in Photoshop using Breezebrowser as a plug-in, and also using Nikon Capture software. (This is slightly unusual, as José's digital SLR is from a different manufacturer.) First the contrast was adjusted through curves (2), with RGB input set at 37 and output set to 60. Next, colour balance (3) was adjusted, including further tweaking of brightness and

contrast to values of +5 and +11 respectively, with colours set at red (–3), green (+13) and blue (–8).

Unsharp mask settings of 10%, 3% and 1% were introduced to sharpen the image (4). Finally, noise was too pronounced for José, so was corrected with a reduction value of 3.

> **4Mp digital compact**
> **TIFF**
> **Photoshop**
> **Breezebrowser plug-in**
> **Nikon Capture**
> **curves**
> **colour balance**
> **brightness/contrast**
> **unsharp mask**
> **noise reduction**
> **silver halide prints**

but were manually balanced. The camera's manual exposure mode was set, and a TIFF file created from the captured image. The shot was taken after a rain shower. José likes the clean atmosphere this creates, as well as the resulting purity of colours. In addition, drops of water added energy to the scene.

! **Search for the best daylight and enrich it with flash, reflectors and diffusers before using the computer to make subtle enhancements.**

José creates images for his own pleasure, and for family and friends. Some are exhibited at a local public tavern. His best shots are usually printed at 20x30cm, or 13x18cm, and output on to silver halide paper.

1/ The original capture.

2/ Modification of the contrast.

3/ Colour changes.

4/ Application of unsharp mask.

5/ The final image.

natural look II

José Ramón Erezuma also created the image shown here. His respect for nature comes across in the way he speaks about his subject. Here, a similar adeptness is evident, not only in the original capture, but also through his mastery of his chosen software.

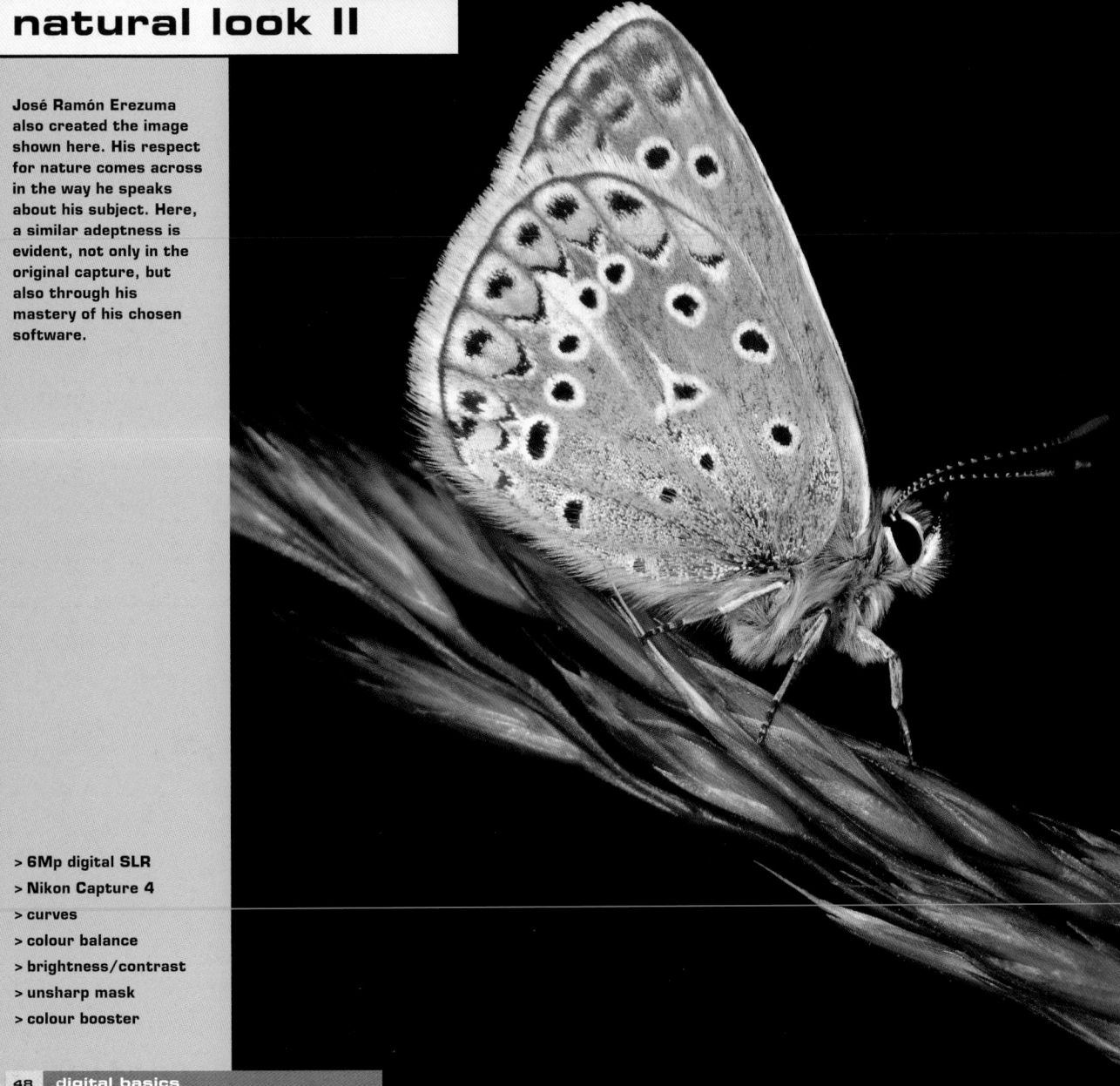

> 6Mp digital SLR
> Nikon Capture 4
> curves
> colour balance
> brightness/contrast
> unsharp mask
> colour booster

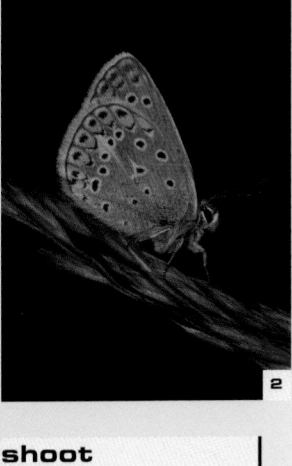

2

shoot

'Polyommatus Icarus' was shot with a 6Mp digital SLR fitted with a 105mm macro lens. Magnification was increased by attaching both a 12mm and a 20mm extension tube between the lens and the camera. Two flash units in manual mode, mounted on flexible branches, as well as the camera's built-in flash with a paper diffuser over the front, provided the main light source.

3 settings

These were the settings at the time this image was taken

Canon EOS 10D
2004/05/25 18:31:48
Image Size: 2048 x 3072

Focal Length: 105mm
Exposure Mode: Manual
Metering Mode: Multi-Pattern
1/200 sec – f/16
Exposure Comp.: 0 EV
Sensitivity:

White Balance:

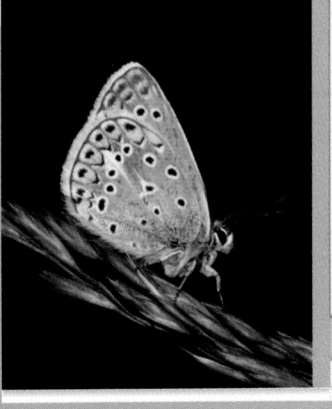

1/ The final image.

2/ The original capture.

3/ Main post-production settings.

4/ The basics of brightness and contrast, plus sharpness, were in need of a small amount of work, as was colour adjustment.

5/ Boosting the colour was undertaken by setting the subject within the software. In this case, the People setting was found to be the best.

6/ Post-capture noise reduction can be an important but subtle enhancement.

4 tool palette

- Curves
- Color Balance

☀ -21
◐ 5
● 9
● 5
● 3

- Unsharp Mask

RGB, 75 %, 5 %, 1 Levels

Color: RGB
Intensity: 75 %
Halo Width: 5 %
Threshold: 1 levels

- Digital DEE
- Color Booster
- Size/Resolution
- Bird's Eye
- Information

5 tool palette

- Color Booster

Target Type: ● People ○ Nature

Level: 50 [Auto]

enhance

Using the default curves when opening the image in Nikon Capture 4 software, José adjusted colour balance in the tool palette to settings of brightness (–21), contrast (+5), red (+9), green (+5) and blue (+3). Unsharp mask was then applied to the RGB image, with settings of 75% (intensity), 5% (halo width) and 1 (threshold) (4). He then applied the finishing touches by setting the People option in Colour Booster to 50 (5).

enjoy

José makes prints from his best images, mostly for pleasure. However, as with most of the images in this book, we came across his work on the Internet.

6 noise reduction

- Advanced RAW
- White Balance
- Noise Reduction

Color Noise Reduction:
◄ [] ► 3

☐ Edge Noise Reduction

- Image Dust Off
- Vignette Control
- Fisheye Lens

noise

Noise is the generic term used to describe pixels that randomly create colours different to others around them in areas where an even tone is sought. This can be prominent in mid-tonal values and especially in darker and shadow regions. Noise occurs, and is exacerbated, due to a number of reasons. Though any sensor generates random 'noise', if this is above a certain level it is too pronounced. Heat can affect a sensor, increasing the effect. Many cameras can reduce the effect in darker areas by taking a 'dark noise' pre-exposure reading, and comparing this to the captured detail of the following exposure, then subtracting the noise from the latter. However, post-capture manual adjustment can also be very useful in correcting noise. In some software programs, a scale of one to ten is set to progressively reduce pixels of specific brightness to darker values (6). Similar correction tools can be found in other programs.

'I took lots of shots until I came up with this one. And this is the best of them all; I know that it isn't a technically good picture as the fur of the cat on the right is out of focus. At that moment it didn't matter, as long as I caught this decisive moment.'

! As with many controls, why not use gaussian blur on small and selected parts of an image, rather than globally. It can help give the impression of depth.

1

play on words

One of the most appealing things about digital capture is that you can view your results immediately. Especially in close-up photography, the eyes cannot distinguish a subject the way a camera can; that is, with close-up the camera can depict details that would go unnoticed by the naked eye. While technically the image here was not necessarily captured as a close-up shot, it has that wonderful 'play on words' that makes it count as an excellent interpretation.

shoot

Tony Georgiadis was a professional wedding photographer in Athens for 20 years. Now based in the Netherlands, he stopped shooting professionally a few years ago, and now takes pictures for his own pleasure. 'All You Need is Love' was shot using a 5Mp compact camera, something Tony always carries with him, wherever he goes. He also has an SLR and a selection of zoom lenses. Since he took up digital photography a few years ago, he has not shot film again, except for a couple of weddings he did for friends.

For this image, Tony was so emotionally moved with what was in front of him that his first reaction was to very slowly take the camera and start shooting as the cats were lying on the couch. Luckily there was a table nearby on which he could steady the camera, and get as close as possible to achieve the framing he wanted. There was not much light, but being afraid of losing this magic moment, Tony didn't even think about setting the white balance to Tungsten.

enhance

Most post-production is undertaken in Photoshop. Tony liked the original framing, so did not spend too much time on it. However, something like variations could be used to correct the colour shift if RAW files have not been shot in-camera [Image > Adjustments > Variations] (2). Tony is not quite sure what he did, as the image was taken over a year ago, but he adjusted the colour shift by tweaking levels using the grey eyedropper, trying to find a grey point (or equivalent mid-tone) somewhere in the picture to give a visual reference (3). This is not

3

> 5Mp digital compact
> Photoshop
> levels
> healing brush
> hue/saturation
> gaussian blur
> inkjet print

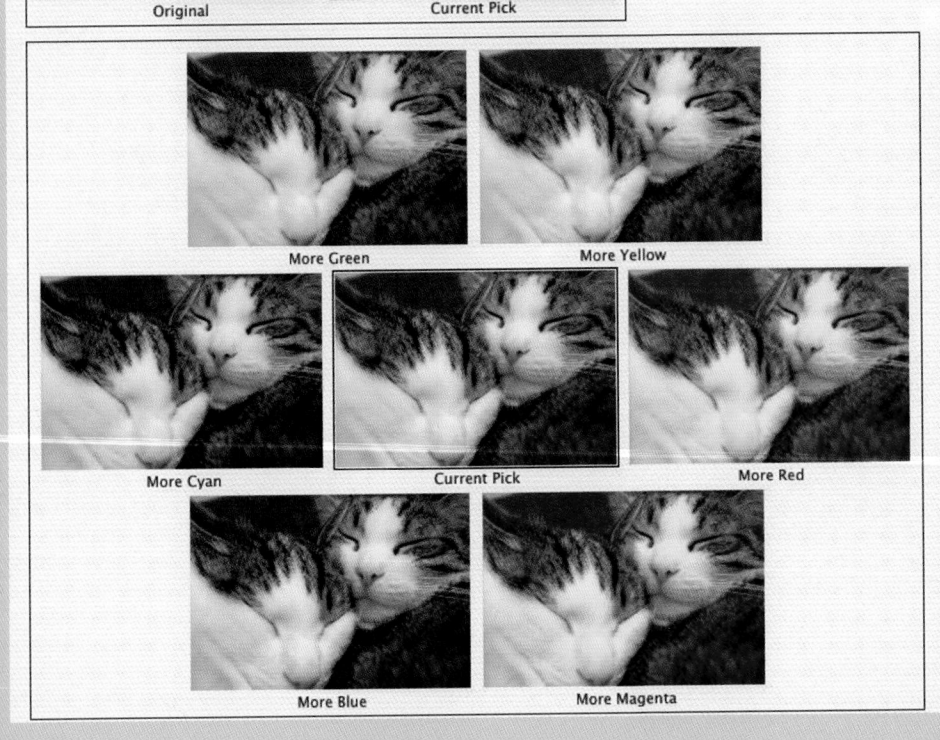

Original Current Pick

More Green More Yellow

More Cyan Current Pick More Red

More Blue More Magenta

○ Shadows
◉ Midtones
○ Highlights
○ Saturation

Fine Coarse

☑ Show Clipping

OK
Cancel
Load...
Save...

Lighter

Current Pick

Darker

conventional in the way many are taught to use Photoshop, but typical in the way professionals have taken old skills into the digital age.

Tony now acknowledges that 'this is one of those moments where shooting in RAW format would do wonders' owing to its post-production potential. Some minor retouching to the nose and corners of the eyes was carried out using the healing brush, and the bottom left of the image was desaturated to eradicate a slight yellow cast (3). Tony gave the image a soft-focus effect to lessen the impact of the out-of-focus part in the bottom right corner, which was due to the fact that it had been shot at the widest aperture (f/2), and the very shallow depth of field that resulted. In addition, this soft-focus effect, usually created via gaussian blur, [Filter > Gaussian Blur] emphasises the tenderness of the moment.

1/ The original was shot with the wrong colour balance and needed a little work to create the cute image we see in the final stage.

2/ A variation in Photoshop is a quick and flexible way to correct for a colour cast, or even introduce some subtle colour. It acts as a big test strip for colour. But remember to calibrate your monitor to get the best from it.

3/ In this image the photographer preferred to use his professional eye to determine the best mid-tone setting for the grey eyedropper in levels. The healing brush and desaturation were also used at this stage.

'By shooting
constantly, you
will acquire a
better eye, and
improve your
results.'

4 gaussian blur

OK

Cancel

☑ Preview

⊟ 100% ⊞

Radius: 0.7 pixels

4/ Gaussian blur in Photoshop,
or a similar program, is a
flexible way to soften an image.

5/ The final image.

enjoy

! When judging images
critically it is best to
select a mid-grey as
your screen background
colour, as this will not
adversely affect your
perception of the image
in the way that a
multicoloured
background will.

Until now, Tony has not sold any
work like this, or had it published.
He mostly uses an A4
photographic-quality inkjet printer,
from which he gets good results.
'All You Need is Love' is not yet
framed, but Tony says he would
select something neutral and
simple, and not anything flashy,
because this would distract from
the image.

! Make sure you are as
familiar as possible
with the software tools
you use to manipulate
your pictures, in order
to give them that extra
punch that leads to the
result you were looking
to achieve in the first
place.

5

'I like to show the unexpected beauty in small things.'

1/ 'Lava' original capture.

2/ The image after cropping.

3/ The contrast was adjusted to enhance the effect.

4/ Colour enhancement came next.

5/ 'Lava' final image.

anytime, anywhere

By making use of everyday household lighting, for example, we can shoot close-up and macro photography at any time. However, it requires imagination to do it well. As with any type of photography, the old guide of 'shape, line and form' is crucial for producing good images. Apart from being cheap and accessible, household lighting offers advantages here in that it is often controllable in its direction and intensity, simply by the positioning of the subject and/or use of simple reflectors.

shoot

Marion Luijten is an artist based in the Netherlands. Her shot 'Lava' has a simple construction. Although Marion uses a 6Mp digital SLR and a 105mm macro lens for much of her photography, this image was captured with a 5Mp digital compact set to its macro focus mode. The shooting aperture was f/7 and the shutter speed 1/50sec, with sensitivity set for 100 ISO. The image was taken at home in Marion's studio while experimenting with different lighting techniques. At the time she didn't have real studio lighting to hand, so after some creative thinking, two halogen desk lamps were used, placed close up behind the rose, though being careful not to leave these in position for too long as the rose would wither in the heat.

enhance

Photoshop was used for post-production, which began with cropping the image. Note that if your camera has sufficient resolution for the final use of the image, you can do this post-capture (3). The contrast was increased to +50, and colour balance adjusted to red (+50) and magenta (–50) (4). The whole process was quick and simple, but effective.

4 colour balance

Color Balance

Color Levels: 50 | –50 | 0

Cyan ——————●—— Red
Magenta ——●———— Green
Yellow ————————●—— Blue

Tone Balance

○ Shadows ● Midtones ○ Highlights
☑ Preserve Luminosity

enjoy

Marion makes prints for contests and exhibitions, and also sells them as gifts. In addition, a number of her images have been used by advertising agencies.

Prints of 20x30cm are produced on her inkjet printer. Images are usually mounted and framed in black, but Marion also uses ivory mounts with aluminium frames.

> 5Mp digital compact
> Photoshop
> crop
> brightness/contrast
> colour balance
> inkjet print

6/ 'Onions' is another of Marion's images, shot with a 105mm macro lens and 6Mp digital SLR. It epitomises one of the beauties of macro and close-up photography – no matter what the lighting, anyone with an eye for detail can achieve such effects.

7/ Taken into Photoshop, 'Onions' was cropped for effect in the final image. Beautiful images are all around us. The captured shot shows shape and form, fundamental to many good images.

3 intermediate levels

'Sun Dial in Blue' by Chris Spracklen.

Levels, filters and duplicate layer were used in the early production stages for this image. Chris Spracklen then used 'soft light' blending effects. A little dodge and burning, as well as boosting the saturation, completed the enhancement.

in this chapter...

Intermediate levels moves things on, adding further techniques to those covered in previous chapters with images from a wider range of subject matter.

just paper

The beauty of close-up photography is that it can be done almost anywhere, using anything as a subject. But this requires imagination, as illustrated by the image in this section, which focuses on greyscale images and their duotone options.

pages 60–61

underwater close-up

By their nature, underwater images are close-up or macro. The examples here were digitised from original film before retouching post-capture. The colours, shapes and beauty of the subject matter make this an increasingly popular arena, but it requires much patience and manual control.

pages 62–63

curve control

There's little to match the flexibility of using curves when it comes to adjusting tonal range and contrast.
Eye-catching images like the one here rightly end up framed for presentation. This section follows the image from capture to display.

pages 64–67

interpolation

Even if the resolution of your digital capture is not great, an image can still fulfil quality demands beyond the basic maths by using interpolation. This spread follows a simple capture through the various stages of post-production.

pages 68–69

moving impressions

Imagination at capture, combined with creative work on the computer, helped create this striking image. To reach its potential, it required a number of effects, each of which is explained in this section.

pages 70–71

'Sometimes when I'm at home (especially on winter nights), I arrange a small set with a black fabric as the background and a small desktop 40-watt lamp, and do some macro or close-up work (mainly using folded paper, or perhaps flowers on top of a white reflecting tile). I love to use just a single light source, hand-held, moving it around until the desired light/shadows are achieved.'

just paper

Still life is one of the most popular aspects of close-up photography, and often consists of easy-to-obtain subjects. However, it is arguably one of the more difficult aspects to do well.

shoot

Though 'Just Paper' has the attention to detail of a professional-quality still life, the photographer, Arturo Nahum from Chile, describes himself as an amateur. Arturo used a 5Mp digital compact, which has a built-in zoom lens. Because of their small sensor size (high pixel concentration), combined with modern high-resolution lenses, digital compacts are ideal for quality close-up capture. However, attention to detail is still required.

Black cloth was used as the background for the image, and the paper was lit simply, by a single 40-watt hand-held lamp. The camera was tripod mounted and triggered remotely. Exposure was set to 1/9sec, with an aperture of f/7.6, which was selected via the camera's program mode. Other set-up features included ISO 100 sensitivity, multipattern metering, auto white balance, and the camera's black-and-white JPEG capture mode.

enhance

Taking the captured JPEG file into Photoshop CS, the image was first cropped to the desired shape using the crop tool, before auto contrast adjustment was carried out [Image >

4 auto colour

Algorithms
- ○ Enhance Monochromatic Contrast
- ◉ Enhance Per Channel Contrast
- ○ Find Dark & Light Colors
- ☐ Snap Neutral Midtones

Cancel

Target Colors & Clipping
Shadows:	Clip: 0.10	%
Midtones:		
Highlights:	Clip: 0.10	%

☐ Save as defaults

2 levels

Channel: RGB

Input Levels: 0 1.00 255

OK
Cancel
Load...
Save...
Auto
Options...

Output Levels: 0 255

☑ Preview

3 curves

Channel: RGB

OK
Cancel
Load...
Save...
Smooth
Auto
Options...

☑ Preview

Input: 53
Output: 81

good news is that you can reset the parameters of auto levels and other auto options by selecting options from the standard levels (2) or curves (3) dialogue boxes. You can then select, for example, the percentage of darker or lighter pixels that will be turned into black or white pixels respectively (4). This can be saved as the new default. If you find, for example, that too few pixels are being placed on the darkest or lightest pixel values, then you can simply increase the percentage of clipping (those changed to black or white). The default setting for clipping on many programs is 5% or 10%.

> 5Mp digital compact
> black-and-white JPEG
> Photoshop CS
> crop tool
> auto contrast
> levels
> greyscale
> duotone
> unsharp mask
> CMYK
> TIFF

! *Auto Levels:* Hitting the auto levels option is a popular way to quickly adjust the tonal range of a digital image. It adjusts the contrast by changing the number of pixels set to black (0) and white (255) levels of brightness. It often works well in correcting a colour cast. However, automation is not foolproof, and it can sometimes get it wrong. With black cloth backgrounds, depending on the lighting and, hence, exposure, pixels may not be black, as desired. The

7

5 duotone options

Type: Duotone

Ink 1: ▨ Black

Ink 2: ▨ PANTONE 1365 C

Ink 3:

Ink 4:

Overprint Colors...

OK
Cancel
Load...
Save...
☑ Preview

Adjustments > Auto Contrast]. However, due to the amount of light reaching the cloth, this adjustment did not make all of the background pixels black (some remained dark grey), so a manual levels adjustment [Image > Adjustments > Levels] corrected for this (2) – see 'Auto Levels' tip below left.

The image was next converted from RGB to greyscale [Image > Mode > Greyscale], even though the captured file was already mono, because an RGB colour mode cannot be used with the flexible duotone options [Image >

6 unsharp mask

OK
Cancel
☑ Preview

⊟ 100% ⊞

Amount: 140 %

Radius: 1.5 pixels

Threshold: 0 levels

Mode > Greyscale > Duotone] that Arturo wished to use.

Arturo selected two inks for his duotone: Black and Pantone 1365 C (5). The image was then enlarged to 250x250mm in 110% increments. Resampling (set to bicubic) created more data to enable this. The image was sharpened with unsharp mask set at 140%, with radius and threshold settings of 1.5 and 0 respectively [Filter > Sharpen > Unsharp Mask] (6). Total post-production time was between 20 and 40 minutes.

enjoy

For reproduction here, the image was converted to CMYK and saved as an uncompressed TIFF file. Arturo sometimes uses an Internet printing service to make prints for his personal collection, and has also started to sell a few images as posters via the Photo4me.com website.

1/ The original was captured as a monochrome image, saving space on the storage card, using all data for tonal range, rather than colour information. A high-resolution image results.

2/ 3/ Opening the standard levels or curves dialogue boxes enables default values to be reset via options.

4/ Auto colour.

5/ Converting an RGB image to greyscale allowed the creative use of duotone toning.

6/ Unsharp mask is usually best applied at the end of post-production.

7/ The duotone applied.

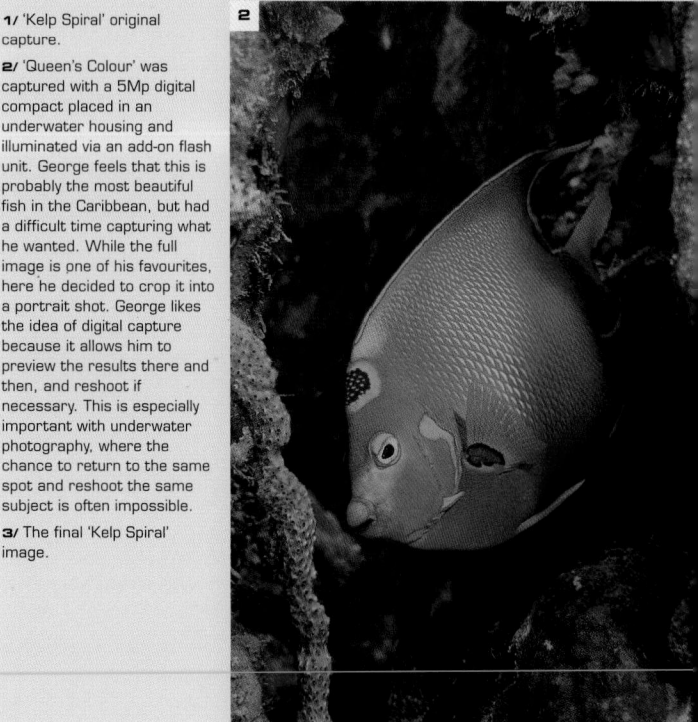

'When I saw this angelfish for the first time, I backed off and waited patiently for the fish to get used to my presence. I adjusted my strobe power and position for a close shot, and then slowly inched forward, breathing slowly (so as not to alarm the fish with my bubbles), until the subject was in the perfect position.'

! Using a large-capacity memory card allows more time underwater.

underwater close-up

Both traditional film and, increasingly, digital capture are used for underwater photography, which involves a number of unique issues photographers need to deal with. These include low lighting levels, subject and camera instability, and the difficulty in getting up close to the subject. Depending on the subject and working conditions, underwater photography can test automatic exposures to the limit, therefore manual control is often the preferred option here.

shoot

'Kelp Spiral' was captured with an underwater camera that accepts interchangeable lenses, and was shot on high-quality 50 ISO colour slide film to create its rich colour saturation, often popular for this type of photography. Professional photographer George Perina swam to the kelp forest off Catalina Island, California, intrigued with the image of the kelp streamer spiralling to the ocean floor. His camera was fitted with a 35mm lens and extension tubes. Underwater, the effects of refraction are different, so this moderately wide angle produced slightly less wide-angle capability compared to its use on land. In addition, light is at a premium, so a high-powered underwater strobe was also used. This is operated manually, using guide numbers, rather than with the camera's TTL flash control, which is now the common approach. The camera was also set to manual exposure mode. Using such manual operations shows that the craft of photography is fundamental to George's image-making.

enhance

Using a 35mm film scanner from the camera manufacturer, the image was scanned using 'Digital ICE' software, which automatically removes surface defects such as dust and scratches. Photoshop was used to colour-correct the image, which looked somewhat 'cool' after scanning, using the colour balance utility, which produced a faithful duplicate of the original slide. George uses both Photoshop and ArcSoft's Photo Studio manipulation software, and either can be used to clone

1/ 'Kelp Spiral' original capture.

2/ 'Queen's Colour' was captured with a 5Mp digital compact placed in an underwater housing and illuminated via an add-on flash unit. George feels that this is probably the most beautiful fish in the Caribbean, but had a difficult time capturing what he wanted. While the full image is one of his favourites, here he decided to crop it into a portrait shot. George likes the idea of digital capture because it allows him to preview the results there and then, and reshoot if necessary. This is especially important with underwater photography, where the chance to return to the same spot and reshoot the same subject is often impossible.

3/ The final 'Kelp Spiral' image.

> 35mm film capture

> scanner

> Photoshop

> colour balance

> clone

> brightness/contrast

> inkjet print

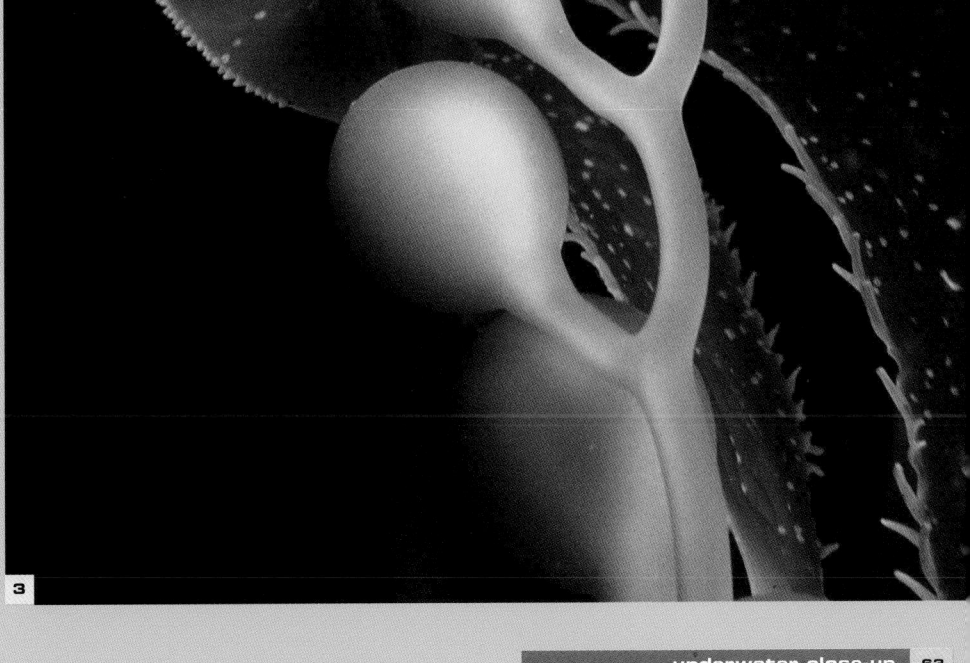



Always use a flash for underwater photography, no matter how much ambient light there is. The flash will bring back colours in the subjects that are lost due to the light absorption of the water.

out unwanted artefacts such as any remaining dust or, in this case, a few elements of backscatter. George's scanner also has a tendency to add contrast, so this was also reduced slightly.

enjoy

Using an inkjet printer and archival inks, George outputs 8x10 inch or 11x14 inch prints, which are displayed at local art galleries. For underwater images he typically uses a black matt background with a thin white border, and a simple black frame – a neutral combination that creates a striking visual.

3

curve control

It is important to get the right contrast and tonal range. However, nothing is cast in stone in this respect, and differing subjects, or even the same subject under different conditions, benefit from individual considerations. Likewise, more or less contrast, for example, can also be of benefit to the end use, depending on the specifics or viewing considerations. Curves in Photoshop, or similar, is a major asset in the control of tonal range and, hence, contrast.

shoot

Enthusiast Heather McFarland shot 'Peas in the Pod' using a tripod-mounted 6Mp Pro SLR fitted with a 60mm macro lens. She particularly liked the colour of the snow peas (or mangetouts), but wanted to capture the seeds inside in an eye-catching way. Taping some of the peas together on her kitchen window ledge to provide the backlighting, the seeds became visible through the pods. Using this natural light from the window behind, and from the window in front of the subject, an exposure of 1/36sec at f/36 was recorded, though the ISO 125 sensitivity was adjusted slightly, by EV +0.3.

enhance

Heather mainly uses Corel Photo-Paint, but also Photoshop and MacBibble software. Curves adjustment (2) and cloning (3) here took around two hours, however, the time spent, of course, in part depends on the processing power of your computer.

Those new to digital imaging often prefer to use the simpler levels option rather than curves. Though levels [Image > Adjustments > Levels] can be used to achieve many of the same results, curves [Image >

Adjustments > Curves] is more flexible in that, unlike levels, it can be used to adjust specific areas of an image; that is, it is a non-linear control. This is a little like dodging and burning-in an image in a wet darkroom when working in black and white, for example. In comparison, levels can only change the contrast on the paper grade, thus changing the whole image.

It does take time to master curves, however, it is worth experimenting because, for tonal curve and contrast

1/ The original capture.

2/ Changes to the tonal range are often necessary with digitally captured shots.

3/ The clone tool is used to get rid of unwanted imperfections.

4/ Non-adjusted curves graph in Photoshop.

2 curves adjustment

Channel: RGB Channels

Curve Style:

Null Balance Options...

julx02765

☐ Display All X: 128 Y: 0

Preview Reset OK Cancel Help

> **6Mp digital SLR**
> **Corel Photo-Paint**
> **Photoshop**
> **MacBibble**
> **curves**
> **clone**
> **inkjet print**

File Edit View Image Effects Mask Object Movie Web Tools Window Help

Custom Clone | Shape ● | Size 55 | Normal | ⚲ 20 | 20

JULX02765.JPG (24-Bit RGB) @33% - Background

File Size: 2178 KB

Use CTRL to constrain, SHIFT+ALT to keep same origin

adjustment, curves allows unequalled control.

Opening curves in Photoshop shows the tones, from left to right, as pixel values 0 (black) to 255 (white) for the original (input) image (4). The vertical scale on the left shows the adjusted (output) values, while the escalating diagonal line represents pixels starting at the shadows, rising through the mid-tones and ending as highlight details. At this stage, no adjustments have been made, so the line is a straight diagonal. (There is also a step-wedge scale to the left, to help

gauge what tonal values you are adjusting.) If you click on the diagonal line and drag, the pixel value changes in brightness, the comparison is shown in the input and output dialogue boxes, and the image changes, showing the effect of the adjustment. Moving a pixel upwards increases brightness; moving it downwards decreases it.

Curves works with both RGB and CMYK images. In both instances, the scale includes pixel brightness values from 0 to 255 or, if you prefer, you can work in percentages from 0 to 100%. This is adjusted back and

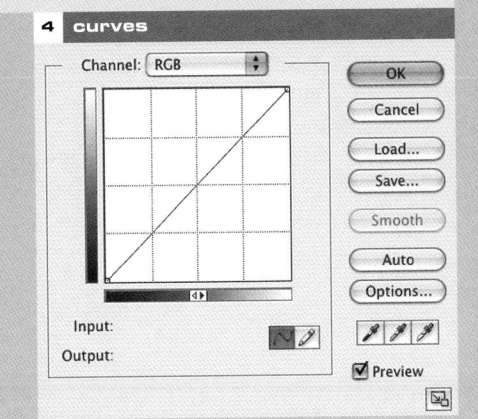

4 curves

Channel: RGB

OK
Cancel
Load...
Save...
Smooth
Auto
Options...

Input:
Output:

☑ Preview

forth by clicking the step-wedge scale along the base. Further control comes from working in a specific colour channel, which is selected from the drop-down menu and can be useful to adjust a colour cast across the whole image or specific areas, and for other colour adjustment.

As a starting point, many images with a normal range of tones benefit from an S-shaped curve. This brightens highlights and darkens the shadows, and is especially good at adding contrast to flat images. In addition, this kind of curve does

not modify the mid-tone values, and adds to the impact of an image whilst retaining a natural look. You can also save and reuse a curve, which can be useful if you have consistent lighting, for example in the case of studio-lit close ups.

6

enjoy

The image was produced as an 11x16 inch inkjet print within a black frame and black matt. Heather makes prints for her own enjoyment, but also sells them on the Internet and through a few fine-art dealers.

7

5

Photoshop also enables numerous points within the tonal range to be locked, maintaining their values even when other values are adjusted. Whatever you do, remember that the steeper the curve, the more contrast it will give.

! **If you prefer, the scales for curves can be reversed in terms of highlight-to-shadow direction by clicking on the adjustment triangles.**

5/ The final image.

6/ 7/ Like levels, curves benefits from Eyedropper tools. These enable quick adjustments to tone and can also be used to correct a colour cast. Particularly useful is the white eyedropper to create a clean white backdrop such as that in this image by Terry Bradwick.

'Light is everything!'

! Images such as the one here often benefit from a workflow using layers.

! Interpolation is in many cases a necessary evil. Maximise your native camera resolution by composing accurately if you can, rather than cropping later on and requiring more interpolation as a result.

interpolation

Most digital cameras have a sensor that uses pixels sensitive to different colours. Red-, green- and blue-sensitive pixels are the most common, creating a mosaic effect. From these, all other colours are created. When increasing image size, the software guesses at, or 'interpolates', the information it already has to create further pixels that take on the colour characteristics needed to make these new pixels.

shoot

Reidar Olsen, a digital enthusiast from Oslo, Norway, using a 6Mp digital SLR fitted with a 90mm macro lens, shot 'Hamilton Pocket Watch 1942' at his home. It was created for a contest, the requirement for which was that movement of the subject be depicted within the image.

enhance

Reidar prefers to use Photoshop and Neat Image software. The latter is a plug-in used to reduce noise. For this image he spent about an hour on post-production, following a logical routine.

Reidar selected the part of the original image he was interested in by cropping and used Neat Image to remove some noise (2). Brightness and contrast were then enhanced, and the image sharpened (3). However, not being quite satisfied, Reidar reintroduced Neat Image. He then applied what he humorously refers to as 'make up', which included cloning out dust and scratches. The yellow

of the image needed a little tweaking of the saturation, before setting the final image size to 300dpi and 800x651 pixels (4/5). Though resolution was reduced through the process, the final image is still impressive.

1/ The original capture.

2/ Neat Image is used to reduce noise.

3/ Contrast adjustment and sharpening.

4/ The final image.

5/ Image size control panel.

6/ For reproduction here, the image was interpolated to 300% of its finished size using the bicubic smoother option.

> 6Mp digital SLR

> Photoshop

> Neat Image

> crop

> brightness/contrast

> unsharp mask

> clone

> saturation

> resizing

image size

Pixel Dimensions: 1.49M

Width: 800 pixels

Height: 651 pixels

Document Size:

Width: 6.77 cm

Height: 5.51 cm

Resolution: 300 pixels/inch

☑ Scale Styles
☐ Constrain Proportions
☑ Resample Image: Bicubic

! Interpolation, or resizing, of an image is common in digital photography. It is necessary when Photoshop, or similar programs, need to create or invent extra pixels to reach the image dimensions required. This can be done in a number of ways. The best option is to use bicubic interpolation, which is common to all modern programs. Technically, this may be slower than some other methods, but it has the advantage in that it provides the smoothest tones, creating more lifelike images. Variations include bicubic smoother and bicubic sharper. The first is intended for big enlargements, the second when reducing an image. You can experiment with these options, but as a default, bicubic interpolation most often produces the best effects.

! Be patient in learning.

enjoy

Reidar makes prints for himself and for his family. His photography is a passion for its own sake.

1

> Always use appropriate light. However, if the only available light is less than fitting, make the most of it by purchasing good digital editing software.

moving impressions

The image here started life – as do many successful images – with imagination. Digital capture is a really ideal tool for its instant feedback when shooting images such as this, the post-production for which included the subtle introduction of movement.

shoot

'Pop Within a Drop' is by Duncan Fauvel, an enthusiast from Wales. Duncan created the original shot by placing a plastic supermarket bag behind a clear cereal bowl. He then dripped water from a cloth held above it, taking photos at short exposure durations, with the macro setting and flash from his compact digital camera.

enhance

Once in Photoshop, the saturation and contrast of the image were increased, helping to create more impact. Duncan selected the water drop with the polygonal lasso tool, and blurred the area around it using the gaussian blur filter after inversing the selected area [Select > Inverse] (1).

Reducing the focus of the background made the drop stand out further, giving the effect of a shallow depth of field. This was important, as such a shallow depth could not be obtained with Duncan's camera. Most digital cameras have a relatively large depth of field, as their sensors are small, as are the pixels that create the resolution. Even relatively moderate apertures such as f/4 have more depth of field as a consequence, compared to say a 35mm sensor with images taken at the same aperture. Of course, this can be an advantage or disadvantage, depending on what you are looking to achieve.

The drop was reselected using the polygonal Lasso, and cut and pasted into a separate document. Duncan used a further filter on the background [Distort > Zigzag] (2), which produced a ripple effect

2 zigzag

OK
Cancel

100%

Amount 10
Ridges 5
Style Pond Ripples

on the background, making the image look as though it was taken from above, looking down on the ripple. The drop was then pasted back into its original position, and a drop from a separate photo pasted in using another layer, just above and across from the larger drop. A smaller drop was then pasted into the centre, giving the appearance of drops falling in a line towards the ripple. The different layers were then merged. Total post-production took about an hour.

> 3Mp digital compact
> Photoshop
> saturation
> contrast
> lasso
> inverse
> gaussian blur
> lasso
> layers
> cut and paste
> zigzag
> cut and paste
> merge layers
> inkjet print

> Of course, we can create the impression of movement in-camera, either through long exposures and a moving subject, or with a long enough exposure and zoom adjustment, or even by panning a camera. This follows a subject across your central vision, releasing the shutter at the mid-point with the subject in the frame. A sharp subject against a blurred background results if this is done correctly.

1/ The original JPEG.

2/ The zigzag filter is important to the overall effect.

3/ The motion blur filter enables you to set the effect and direction of movement.

4/ The final image.

4

3 motion blur

OK
Cancel
☑ Preview

⊟ 100% ⊞

Angle: 0 °

Distance: 139 pixels

movement

Using the zigzag filter, a selected area is distorted towards the edges, across a specified number of pixels. By defining the number of ridges, you decide the number of direction reversals of the zigzag from the middle of the selection to the edge, as well as the direction of movement.

Alternatively, among the blur filter options is another useful utility for creating the impression of movement – motion blur [Filter > Blur > Motion Blur] (3). Quite different in effect, this is nevertheless very useful when used sensibly, as is the less-often used wind filter [Filter > Stylise > Wind].

enjoy

Duncan makes prints for personal enjoyment and also to sell occasionally through shops and to individuals. The image here was printed at 10x10 inch on his home printer.

4 working with colour

'Sea Polyps' by Heather McFarland.

This image was created using a digital
compact in its macro mode. Aperture
priority mode control gave a 1/24sec at
f/3.6 exposure, but with an EV –1.0
compensation. Post-production, the
image was produced as an 11x14 inch
print in her home.

in this chapter...

This chapter takes a peak at the world of colour, from colour harmony to manipulation. Various subjects are used to show the different ways, and reasons why, photographers enhance colour reproduction.

colour harmony

Colour harmony is often a fundamental part of the success of an image. This section looks at how a striking example of this was created.

pages 76–77

quick masks I

There are numerous ways to manipulate specific areas of an image, but few are as useful as masks, as demonstrated by the results achieved in the image here.

pages 78–79

quick masks II

This section features a further, more detailed image, constructed using quick mask and other techniques such as the channel mixer and the motion blur filter.

pages 80–81

keeping the noise down

Noise can intrude on the whole, or parts of, an image. This section suggests a number of ways in which you can control the effects of noise.

pages 82–83

worlds within worlds

The wonderful close-up here looks like a simple image. However, it took imagination and step-by-step manipulation to achieve the effect.

pages 84–85

start to finish

Colour is a huge subject area. In the eye-catching example here, we follow basic adjustments through to the principles behind how the photographer prepares his work for printing, then presentation.

pages 86–87

getting your profile right

There's little point putting in large amounts of time and effort elsewhere in your photography, if your monitor does not show colours accurately. The images in this section emphasise the importance of regularly calibrating your monitor.

pages 88–91

shoot

Digital enthusiast June Marie Sobrito is based in New York. 'Incredible Edible' was shot for an online digital photo contest. The set-up was placed on June's kitchen table and lit by one overhead incandescent light bulb. Although June also uses a digital SLR, this particular image was captured with a 5Mp SLR with a fixed zoom lens.

colour harmony

The images here demonstrate one of the basic tenets of good colour photography – colour harmony. Whilst, technically, discord between colours is acceptable within digital photography, most images benefit from considered combinations. Here, the beauty of digital post-production is that colours can be modified or completely changed.

> **5Mp digital SLR**
> **RAW**
> **Photoshop**
> **auto levels**
> **hue/saturation**
> **Internet**

enhance

Taking the 5.5Mb RAW file image into Photoshop, enhancing the colour harmony was simple. Auto levels [Image > Adjustments > Auto Levels] was used for basic adjustment of colour and contrast, followed by a small increase in saturation [Image > Adjustment > Hue/Saturation] for effect. June likes to use digital control for its ability to make the ordinary look extraordinary, and close-up brings out details in an object which, from a distance, would usually be a blur to the naked eye.

enjoy

June puts her images on the Internet.

! Shoot in manual mode and underexpose by 1 to 1.5 stops. Shadow details can be brought out in Photoshop, but highlights blown are lost.

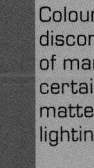

matching colour

Colour harmony, rather than discord, is in itself the subject of many books. And there is certainly no denying that no matter what the subject, lighting or composition, getting colours that work together to help convey a message is as important as anything else in colour photography. Different cultures view colours differently, as do individuals. If your image is not quite there, and you cannot define why, then why not subtly adjust the colours, as this can often make a big difference. The easiest option may be to use auto colour, or similar, in programs such as Photoshop. However, though such settings can work well and are definitely worth a quick look, they may also misinterpret the data in relation to what you are trying to achieve.

1/ 'Incredible Edible' original capture.

2/ The final image.

3/ Shot in the photographer's living room, using natural light from the windows, 'Season', also by June Marie Sobrito, was intended as a tribute to the start of the baseball season, and is another example of colour in harmony.

4/ The final image of 'Season'.

quick masks I

As its name suggests, this is a fast way to select an area, either to be worked on or masked off. The quick mask buttons are found in the toolbox (2). A mask is a greyscale image, and most editing capabilities that can be used with a greyscale image can be applied to a quick mask. For example, if you select the area you want to leave unchanged, clicking on the quick mask button creates the mask, showing the masked off areas in red. You can add to, or take away from this by using paint tools. These work in black and white; black adds to the mask, and white reduces it. If you open the channels window in Photoshop [Window > Channels], you will see the mask is added as a new, temporary alpha channel. Here, the black areas show the masked section, and the white the unmasked area. Partially selected areas are shown as shades of grey.

> **4Mp digital compact**
> **JPEG**
> **crop**
> **curves**
> **magic wand**
> **mask**
> **layers**
> **paint bucket**
> **quick mask**
> **levels**
> **Internet**

shoot

Edinburgh-based Martin W. Paul created 'Leaving Home' with a 4Mp digital compact camera and an exposure of f/32 and 1/30sec. However, the image required some creative post-production work to create what he had intended.

3 curves

4 magic wand

enhance

The captured JPEG was cropped tighter to maximise the composition, before curves was applied to brighten up the shot (3). The sky was selected using the magic wand tool (4), and saved as a mask. A new layer with a suitable blue-sky adjustment was applied, using the mask to the main image layer. Colour was selected from the paint bucket (5). Still not

1/ The original capture JPEG.

2/ Quick masks are turned on and off via the toolbox.

3/ Curves are adjusted to brighten up the shot.

4/ The sky was selected with the magic wand tool.

5/ Paint bucket was used to further enhance the sky, for more impact.

5 paint bucket

quite happy with the resulting image, Martin painted a quick mask (6) over the areas he wanted to brighten up further, before adjusting levels (7) to complete the effect.

7 levels

Channel: RGB

Input Levels: 8 | 1.04 | 238

OK
Cancel
Load...
Save...
Auto
Options...

Output Levels: 0 | 250

☑ Preview

6 quick mask

History | Layers | Channels

Normal | Opacity: 100%

Lock: ☐ ✎ ✛ 🔒 | Fill: 100%

👁 Background...

👁 blue sky

👁 Background 🔒

6/ Quick mask brightened up selected areas of the image.

7/ Final levels adjustment.

8/ The final image.

enjoy

Martin usually makes prints for his own enjoyment and to sell, although he is yet to print this image, which for reproduction in this book was sourced from the Internet.

1/ The original image.

2/ As standard the mask area is shown in red.

3/ The mask was loaded over the selection.

4/ The motion blur filter is ideal for this kind of image and easy to use with its preview window and simple controls of pixels and angle.

5/ The channel mixer is a great way to adjust monochrome tones.

6/ The final image.

quick masks II

You cannot always capture the best image in-camera. In the past, this could only be redressed in darkrooms. However, in the digital 'darkroom', images can be saved or enhanced to a much greater extent, to create an image that matches your initial vision, or even betters it. Masking areas in order to work on specific areas of an image can be a fundamental benefit here.

shoot

Martin W. Paul likes the fact that you can get great macro results from cameras that don't cost the earth. 'Flight of a Bumble Bee' was captured on a 4Mp digital compact. A good-quality zoom lens (in this case a 4x optical zoom) can make for a flexible lens for close-up work, but you might want to consider adding a close-up lens to enable greater magnification if this is an option.

2 quick mask

History	Layers	**Channels**	
	RGB		⌘~
	Red		⌘1
	Green		⌘2
	Blue		⌘3
	Bee		⌘4
	Quick Mask		⌘5

3 layers

History	Layers	Channels	
Normal		Opacity: 100%	
Lock:		Fill: 100%	
		Background copy	
		Background	

enhance

Martin prefers to use Photoshop, as well as Image Capture software from Apple. Here, in Photoshop, quick mask was used to create a mask for the bee (2). Next, the background layer was duplicated and the mask loaded as a selection over the top (3). The motion blur filter [Filter > Blur > Motion Blur] was applied with a distance value of 120 pixels (4). A channel mixer adjustment layer was then introduced (5) and, making sure 'monochrome' was checked, Martin set the red channel at +45, the green channel at +45, and the blue channel at 0, which resulted in a suitable mono background. Finally, the image was cropped to lose some of the extraneous background.

> 4Mp digital compact

> Photoshop

> quick mask

> duplicate layer

> load mask

> motion blur

> channel mixer

> crop

> Internet

4 motion blur

OK
Cancel
☐ Preview

100%

Angle: 0 °

Distance: 120 pixels

5 channel mixer

Output Channel: Gray

Source Channels

Red: 45 %

Green: 45 %

Blue: 0 %

Constant: 0 %

☑ Monochrome

OK
Cancel
Load...
Save...
☑ Preview

6

enjoy

Martin makes prints for his own enjoyment and also sells them through his website. It is important to future-proof your final use options by shooting as large a file as possible at capture, and preferably in RAW format. This ensures the maximum flexibility of use, no matter how you decide to use the image.

1/ The original was a good composition but needed post-capture work to make it technically acceptable.

2/ Some programs offer more options to control noise than others. Nikon Capture controls for differing causes of what we collectively call 'noise'.

3/ Tone curve adjustment changes contrast.

keeping the noise down

In digital photography, the term 'noise' is used to describe a number of causes and effects. Here we look at one example where noise reduction has been employed, and the common options to correct for noise post-capture. (Of course, if your camera has a noise-reduction facility, you should use this first, if it is practical to do so.) It is a common misconception that noise is visible only in dark areas; it can also show itself in mid-tones or, for example, in highlight details, both of which are regularly recorded in close-up images.

> 6Mp digital **SLR**
> **Photoshop**
> noise reduction plug-in
> **Corel Photo-Paint**
> tone curve
> **Photoshop plug-in**
> colour correction
> clone
> silver halide print
> inkjet print
> Internet

shoot

The 6Mp Pro SLR Heather McFarland used was fitted with a 60mm macro lens, capable of a maximum 1:1 magnification (though it was not set to this maximum value). 'Greenery' was taken at a local greenhouse, the owners of which allowed Heather to come in and shoot in exchange for prints to hang in their shop.

The leaves of the large tropical plant were backlit with light from the greenhouse roof. Heather had to shoot from underneath the leaves, up towards the ceiling – a tough angle – which meant the image needed to be hand-held. She wanted sufficient depth of field to get the subject in sharp focus across the recorded area. She bumped up the ISO to 800 in order to make use of an f/25 shooting aperture, avoiding camera shake with a 1/50sec shutter speed. She was also able to rest her camera on the display table, further increasing the stability. Aperture priority exposure control was used, with an EV +0.3 compensation adjustment.

! **Many programs have a standard noise-reduction control to reduce noise in photographs taken at fast ISO ratings or at slow shutter speeds. In Nikon Capture (2), the slider is moved to select a value from zero noise reduction to its maximum effect. Checking edge noise reduction reduces noise around edges, providing a sharper outline. For the manufacturer's RAW files, this program also includes colour moiré reduction. This can be useful in close-ups with highly detailed patterns made up of small contrasting colours, and should be applied before converting the file into another format.**

enhance

Post-processing began with Fred Miranda's ISO Pro Photoshop action, which reduces noise created by the high ISO setting. Fred Miranda Photoshop actions are available for a variety of image-processing procedures that are otherwise quite tedious and time-consuming if carried out manually. (Check out www.fredmiranda.com for more information.) Heather next applied a tone curve adjustment in Corel Photo-Paint

(3) before removing a small amount of yellow using the Photoshop plug-in Vivid Details Test Strip. The imperfections in the leaf were cloned out. Total post-production time was about two hours.

❗ *Median Filter*: This filter is found in many software programs (4). It merges the brightness of pixels within a selected area, reducing the effects of noise by removing pixels whose values differ greatly from adjacent pixel values and replacing them with an average value.

4/ The median filter is found in many programs, here Graphic Converter. It reduces the effects of noise in selected areas by removing pixels that have too great a brightness difference to the pixels around them.

5/ The final image.

enjoy

Making prints mostly for her own enjoyment, Heather has also sold this image as 16x11 inch prints, output on a Durst Lambda (silver halide) and an inkjet printer. The image is also on the photographer's website.

4 median

Picture Before After

Zoom

Radius 2 Reset

☑ Full Screen Preview Cancel OK

'As with film photography, for digital work it is best to use a tripod, remote trigger, the lowest possible **ISO** and, if possible, shoot in **RAW** format. Camera quality is not too important, but always buy the best lenses you can afford.'

worlds within worlds

'Vegetarian Nude' was created from a shot of a cactus often used by young people who are in love to etch a heart with their initials inside in the leaves. The photographer really liked the colour and texture of the cactus, but where could he take the image post-capture?

shoot

The image was shot by Chile-based enthusiast Arturo Nahum using a 4Mp but highly specified digital camera with an exposure of 1/400sec at f/4. Its zoom lens was set to a 21mm focal length. The file's Exchange Information Format (Exif) data also showed that multipattern metering was used and the lens focused 30cm away. The original JPEG file was 1.7Mb.

4 image size

Pixel Dimensions: 11.1M
Width: 2272 pixels
Height: 1704 pixels

OK
Cancel
Auto...

Document Size:
Width: 7.573 inches
Height: 5.68 inches
Resolution: 300 pixels/inch

☑ Scale Styles
☑ Constrain Proportions
☐ Resample Image: Bicubic

enhance

During post-processing, Arturo saw the shape of a woman's breast in parts of the cactus, and decided to create the second image out of the first to enhance this, which took around half an hour. The image was opened in Photoshop and first rotated counter-clockwise [Image > Rotate Canvas > 90 CCW]. The crop tool was then selected from the tool palette to square the image, cutting out the unwanted parts.

The magic wand tool, with tolerance set to 10, was used to select the blurred background (2). This was then inversed [Select > Inverse] to select the 'breast'. Using keyboard shortcut commands – Ctrl+C and Ctrl+V – this was copied and pasted into a new layer. Selecting the background layer again, gaussian blur was applied twice with the radius value set at 1.2 (3). Back to the foreground layer, this was rotated [Edit > Transform >

2 magic wand settings

Tolerance: 10 ☑ Anti-aliased ☑ Contiguous ☐ Use All Layers

3 gaussian blur

OK
Cancel
☑ Preview

100%

Radius: 1.2 pixels

180dpi to 300dpi in the image size dialogue box with resample image deselected (4), it was then enlarged by 10%, again using the image size dialogue box, this time with resample image selected.

To frame the image, Arturo used the canvas size dialogue, selecting white as the background colour. With relative checked, he

Rotate] until the desired angle was achieved.

Unsharp mask with radius and amount settings of 0.2 and 176 respectively, was applied to the foreground layer, making the image stand out more and creating a three-dimensional effect. The layers were then flattened and a final crop made to tidy up the image. After increasing the image size from

5 settings

Description
Camera Data 1
Camera Data 2
Categories
History
Origin
Advanced

Description
Document Title:
Author: Arturo Nahum, anahum@mi.cl ,
Description: a montage created with a crop from a cactus clo up
Description Writer:
Keywords:

Commas can be used to separate keywo

Copyright Status: Unknown
Copyright Notice: (c) 2002, 2004 Arturo Nahum

Copyright Info URL:
Go To URL

Powered By
xmp

Created: 1/2/04
Modified: 1/2/04

Application: Adob...otosh
Format: image/tiff

Cancel

> 4Mp digital capture
> JPEG
> Photoshop
> rotate
> crop
> magic wand
> inverse
> copy
> paste
> layer
> gaussian blur
> rotate
> unsharp mask
> flatten
> crop
> image size
> canvas size
> TIFF

! Use keyboard
 shortcuts to simplify
 your workflow.

added a white border to the perimeter then, changing the background colour by picking from the cactus itself using the eyedropper (6), he repeated the step to add the second, non-white border (with relative unchecked). The image was then saved as a TIFF file.

7

6 colour picker

Select canvas extension color:

OK
Cancel
Custom

H: 160 ° L: 50
S: 10 % a: -7
B: 48 % b: 0
R: 111 C: 64 %
G: 123 M: 39 %
B: 119 Y: 47 %
6F7B77 K: 12 %

☐ Only Web Colors

1/ The original capture had potential, but further work was needed.

2/ The magic wand tool is one of the more widely used selection methods.

3/ Gaussian blur helped create the smooth background and 3D effect.

4/ The dpi was reset to 300dpi.

5/ Important information attached to the meta data of an image can be added to the image settings and can help a third party (as well as the photographer) see details such as these at a glance. Copyright information can also be included amongst this information.

6/ Clicking on a particular tone within an image with the eyedropper sets that tone as the foreground colour, ready for extending the canvas.

7/ The final image.

enjoy

At the moment this is only an Internet-based image. For reproduction here it was supplied as a 21.6Mb 8-bit RGB TIFF file.

1

'Spend time learning as much as you can about digital image processing and how to use your editing software, by experimenting, reading books, and via Internet-based forums and tutorials.'

1/ 'Autumn Beech' original capture.

2/ 'Autumn Beech' final image.

3/ Brian uses all of the control within Levels, including the adjustment for mid-tone values.

4/ The original capture for 'Seasonal' was adjusted for brightness/contrast, with a small increase in colour saturation and some unsharp mask.

5/ Taken at Brian's home, 'Seasonal' is a shot of a leaf from a crepe myrtle shrub, which turns a beautiful deep red during late autumn.

start to finish

Digital compact cameras are often a very good choice for close-up photography because the majority have small sensors, and therefore offer a significantly increased depth of field for a given magnification compared to 35mm sensors or larger alternatives. They also focus very close, enabling a high magnification to be obtained.

shoot

Brian Zimmerman, a professional photographer based in Virginia, USA, captured 'Autumn Beech' at Douthat State Park in Western Virginia. He used a 3Mp digital camera with a built-in 37–370mm IS (image stabilised) lens and the addition of a 500D close-up lens. This allows a subject of only about an inch in length to be captured from about 12 inches, and the maximum focal length. Exposure was 1/100sec at f/8.

2

enhance

The first step here was to adjust the contrast and brightness, which can be done using the levels control in Photoshop [Image > Adjustment > Levels], and using the histogram to adjust how the pixels are distributed in relation to their brightness (4). Brian played around with the three triangles under the graph, moving them right or left to adjust the brightness values of the image until he got what he wanted. Very slight alterations were then made to the saturation in order to boost the colours [Image > Adjustments > Hue/Saturation].

If an image lacks clarity, appearing foggy or washed out, Brian reaches for unsharp mask in Photoshop [Filter > Sharpen > Unsharp Mask] or the clarify filter in Paint Shop Pro. Unsharp mask settings are typically set for a radius of 50 and strength of 10 to 15. At this stage, if the image has any minor defects, such as a spot of dirt or discoloration, the clone tool comes into play.

By selecting save as from the file menu, Brian then saves a copy of the image with a name to indicate how it has been adjusted (an important task we should all do on a regular basis when making multiple copies of images). For example, he will add an 'a' for 'adjusted', to note the image has been edited, or 'c' for 'cropped', 'r' for 'resized' and 's' for 'sharpened'. In addition, 5x7 after the 'c', for instance, denotes that the image was cropped to fit a 5x7 print.

> 3Mp digital SLR

> Photoshop

> levels

> saturation

> unsharp mask

> clone

> rename

3

5

enjoy

'I thought its deep
red colour would
make an interesting
macro shot when
highlighted with
some oblique
sunlight. The
exposure was
1/20sec with an
aperture of f/8 at
full zoom with the
close-up lens
attached, from about
a foot away.'

Brian has yet to print this
particular image, but has a
thought-through approach to
printing in general, depending
on the print size. First he crops
the image to the desired print
dimensions, and then sharpens
using the unsharp mask tool,
set to a radius of 1.0 and
strength of 100 or thereabouts.
This is particularly important if
the image has not been
sharpened previously, and is
usually the best time to apply
this effect. If the image lacks
enough pixels to produce a
good-quality print at the desired
print size, the image size is

! Image-stabilised (IS)
lenses can be a
particular advantage for
close-up photography,
especially where no
tripod is to hand.

4 levels

sometimes increased using
interpolation. For Internet use,
Brian uses a smaller radius than
for a printed image, roughly
between 0.3 and 0.5,
depending on the image, plus a
strength of between 50 and
200. If the image is still not
sharp enough, he uses a further
sharpening step, but with a
much lower strength value.
Brian usually opts for either
inkjet prints up to 8x10 inch, or
traditional photographic laser
prints produced by commercial

photo labs up to 20x30 inch in
size. He then mounts prints on
either 1/8 inch or 3/16 inch
foam-core board and places
them in a metal frame. The
frames are usually black or gold,
cut to size, from a commercial
supplier. Matt colours are
chosen to suit the individual
image, using either a single or
double matt technique.

Both of the images shown here
have been exhibited at an
international show.

1

> Watch the histogram at the time the picture is taken, to make sure the exposure is correct. In particular, look for a spike to the right, indicating blown highlights. If in doubt, always underexpose because detail can be brought out later on the computer.

getting your profile right

Profiling has an important role in that it allows an output image to closely match that viewed onscreen. In this example, profiling meant that the best results for a specific printer and paper type could be achieved.

shoot

'Hibiscus' started life on a 5Mp digital compact. Stephen Bonk, from New Jersey, USA, took it in his backyard as the start of a macro flower photo collection. His son assisted by holding a piece of black velvet in the background. The sky was overcast, with just a hint of sun peaking through, giving mostly flat lighting, which is often beneficial for close ups as it reduces annoying shadows. Approximately 30 shots were taken using various perspectives as well as different aperture and shutter-speed combinations. Stephen determined this one to be the best.

enhance

Approximately two hours were spent working on the image in Photoshop. First the colour was corrected using curves, followed by some touching up in the bottom left corner to get rid of the background here. Next Stephen needed to fix the black background to the right of the image, where a few lighter streaks were visible. He did this by selecting a black pixel from the background and filling the entire right side with this exact colour. The NIK Sharpener Pro plug-in added the finishing touches.

> 5Mp digital compact
> Photoshop
> curves
> NIK Sharpener Pro
> QImage
> inkjet print

1/ The original image benefited from the flat lighting.

2/ Software contains many different options for getting the most from colour and your workflow. Ideally, a spyder should be used to measure your monitor's response to test stimuli (see page 90).

3/ The final image.

2 colour settings

Settings: Custom

☑ Advanced Mode

Working Spaces
RGB: Adobe RGB (1998)
CMYK: Euroscale Coated v2
Gray: Gray Gamma 1.8
Spot: Dot Gain 15%

Color Management Policies
RGB: Preserve Embedded Profiles
CMYK: Preserve Embedded Profiles
Gray: Preserve Embedded Profiles
Profile Mismatches: ☑ Ask When Opening ☑ Ask When Pasting
Missing Profiles: ☑ Ask When Opening

Conversion Options
Engine: Adobe (ACE)
Intent: Relative Colorimetric
☑ Use Black Point Compensation ☑ Use Dither (8–bit/channel images)

Advanced Controls
☐ Desaturate Monitor Colors By: 20 %
☐ Blend RGB Colors Using Gamma: 1.00

Description

OK
Cancel
Load...
Save...
☑ Preview

enjoy

Whilst Stephen shoots primarily for his own enjoyment and online photo competitions, he would like to expand this commercially in the future. He has printed various sizes of this image on an inkjet printer (maximum size 10x8 inch, mounted in a white matt), using paper from different manufacturers and QImage software with vector interpolation and ICC profile for the specific printer and paper type used. The image has also been displayed on various photo contest websites.

! Although it is recommended, if you choose not to use profiling, any changes you make to an image will take longer and be more hit and miss. However, options such as variations in Photoshop can be used to change the characteristics of an image you have printed in a closed-loop system. If the colour is not right, for example if the image is too 'red' in print, select a variation with less red from the available options and reprint.

3

4

monitor your monitor

Most digital photography operates in what we term a 'closed-loop system'. That is, the photographer captures the view and prints the image using the equipment at his or her disposal. Of course, if you can get your images to look the way you want them to at the end of your production chain, this is all that matters. However, profiling your monitor is vital. Although adjustments can be made using computer software, though

good these are not the best option. Professionals use a device called a spyder, which physically measures your monitor's response to test prompts. It costs a little, but you will soon appreciate the benefits of regularly profiling your monitor, especially if you send your work out to third parties to print or publish. Advice varies, but profiling once a month is a good guide.

ideal world

Following are a few pointers to help you get the most from your 'digital' darkroom. First, always let your monitor warm up for around 30 minutes before undertaking critical colour work. There should be no changeable ambient light affecting either the screen or your viewing environment, and artificial lighting in the digital darkroom should be balanced to roughly

the same brightness level as your monitor. The walls should be painted preferably in a mid-tone grey, and you should avoid wearing colours that will reflect back on to the screen, so black shirts are recommended.

Regular calibration of the monitor is a must. This creates a new profile each time, which should be used by your system.

4/ A spyder is a valuable tool for critical calibration. It sits over a screen and measures colour responses interpreted by accompanying software. It is best to calibrate your monitor using a spyder at least once a month.

5/ 6/ 7/ Many computers come with software to calibrate your monitor that relies on your eyesight as a guide. Though this is not quite as good as measuring the output with a spyder, it can still be effective.

5 display calibration assistant

Introduction

- Introduction
- Set Up
- Native Gamma
- Target Gamma
- Target White Point
- Admin
- Name
- Conclusion

Welcome to the Apple Display Calibrator Assistant!

This assistant will help you calibrate your display and create a custom ColorSync profile. With a properly calibrated display, the system and other software that uses ColorSync can better display images in their intended colors.

Display calibration involves several steps:
(some steps may be skipped on some displays)

- Adjust the display's brightness and contrast
- Determine the display's native luminance response curve
- Choose a desired response curve gamma
- Choose a desired white point (warmth or coolness of white)

☐ Expert Mode – This turns on extra options.

Click the continue button below to begin.

(Go Back)　(Continue)

6 display calibration assistant

Select a target gamma

- Introduction
- Set Up
- Native Gamma
- Target Gamma
- Target White Point
- Admin
- Name
- Conclusion

Select your desired gamma setting for this display. This will adjust the overall contrast of the display. Watch the picture on the right to see the effect of the different options. In most cases, it is best to use the Mac Standard gamma of 1.8.

Linear Gamma　　Mac Standard　　PC Standard

1.0　　　1.8　　　2.2

☐ Use native gamma

Target Gamma = 1.82

After you have done this step, click the continue button.

(Go Back)　(Continue)

8/ If you do not calibrate your monitor, the image you see onscreen can be very different to the one that prints, or that which others see when opening the file. This shot, by Miguel Lasa, was captured digitally, and simple adjustments were made to increase saturation and contrast.

On Apple Mac computers, for example, Colorsync uses the new profile to convert colours from incoming images. For images that will be reproduced in books and magazines, many people opt for the Adobe 1998 colour space setting in-camera. Where images will be used only on the Internet, or for closed-loop inkjet printing, it is best to use an sRGB colour space alternative. Nothing is cast in stone, but each has benefits over the other, depending on the end use of your work.

7 display calibration assistant

Select a target white point

- ⊖ Introduction
- ⊖ Set Up
- ⊖ Native Gamma
- ⊖ Target Gamma
- ⊖ Target White Point
- ● Admin
- ● Name
- ● Conclusion

Select the white point setting you want for your display. This will adjust the overall tint color if the display. In most cases it is best to use the display's native with point or a standard white point such as D50 or D65.

D50 D65 9300

5000 6000 7000 8000 9000

☐ Use native white point

Target White = 6487 °K

After you have done this step, click the continue button.

Go Back Continue

5 working in mono

'Alien Fruit' by John Clements.

John Clements created this monochrome version of the colourful and surreal 'Alien Fruit' (see pages 120–121). It was desaturated to leave the black-and-white version quite different to the colour original, with a mood of its own.

in this chapter...

The wonderful world of mono still has its place in close-up and macro photography. This chapter looks at a few examples where colour has been removed, and black-and-white results enhanced. There are also some interesting stories behind the images.

desaturate

From colour capture, through scanning and post-production to fine-art prints, this spread tells the story of an image with careful consideration of each vital stage of the workflow. This includes the desaturate option, removing colour but not throwing it away.

pages 96–97

monochrome up close

There are numerous ways to
create a monochrome image,
beginning in-camera. This section
gives an overview of the more
popular options for doing so.

pages 98–99

lab colour

This is an underutilised and little
understood option. The image in
this section starts off as a colour
original, but ends up a
monochrome after a considered
approach using the lab colour
mode facility.

pages 100–103

something from nothing

Things do not always end up as
you have envisaged. The image
here was originally an 'extra'
whilst the photographer was
shooting something else!

pages 104–107

! Desaturating an image gives neutral black-and-white tones.

desaturate

shoot

Some things just look better in mono. There are many ways in which you can create a monochrome image and each has its own advantages. One popular and easy route is to desaturate the image of its colour, producing a traditional black-and-white image with a neutral tone. Here, George Mallis did just that, to realise the potential of an image capture with a rather unusual perspective.

'Boundary Line Number 1' was taken with a 35mm film camera fitted with an 18–35mm ultra wide-angle zoom lens. George used high-quality 100 ISO slide emulsion film. Laying flat on his back and looking up, he achieved this unusual perspective. Although he found the view compelling, some of the background elements detracted from his original concept.

1/ The original capture gave an unusual perspective.

2/ 3/ Combined here with the clone tool, the magic wand is one of the most useful tools for selecting specific areas. Changing the tolerance on the tool bar will help if it misses parts you originally wanted to select, or captures too many.

2 clone tool

enhance

The image was scanned on a desktop 35mm unit, producing a 40Mb RGB TIFF file. George was then able to work on the image in Photoshop. He used the magic wand tool to select the background (2/3), before eliminating the distracting elements with the cloning stamp, using varying opacities, stamp sizes and feathering values. This created a simplified visual background, comprising the landmass as a silhouette, plus the sky with its pleasing colour gradation. Often a simpler composition is more effective.

It was at this point that George decided the image might be more effective in black and white. Desaturating the file [Image > Adjustments > Desaturate] (4) achieved the subtle gradations of shade that here give emphasis to the lines of what appeared to be an imposing structure.

> 35mm film camera
> scan
> RGB TIFF
> Photoshop
> magic wand
> clone
> desaturate
> CMYK TIFF
> fine art print

3 magic wand

Tolerance: 32 ☑ Anti-aliased ☑ Contiguous ☐ Use All Layers

why desaturate?

Deciding which way to create a monochrome image from colour is complicated by the number and flexibility of the options available in the many suitable software programs, and within some cameras. Using the desaturate command, the image has its RGB colour values removed so that just the lightness values remain [7]. This is achieved equally across the RGB values and is the equivalent of setting the saturation control in hue/saturation to –100.

7 | **hue/saturation**

6

5

4/ Using the clone tool, elements of the original capture were removed, leaving a simpler, yet more effective image to be converted to mono.

5/ The final image.

6/ Instamat Fine Art Print.

7/ Desaturate is the equivalent of setting saturation to a zero amount (–100 value). It takes away the effect of colour but retains the lightness values for each pixel.

enjoy

The image was converted into a CMYK TIFF file for reproduction in this book. However, George makes an interesting, alternative final image called an Instamat Fine Art Print. Starting with a smaller image size, using Photoshop, the canvas size is increased to either 8x10 inch or 9x12 inch, giving a greater area around it. Using the rectangular marquis tool, and filling the selection with colour using the paint bucket, creates the surrounding area, or 'matting'. Textures are added using Photoshop texture filters.

"Boundary Line No. 4" George Mallis

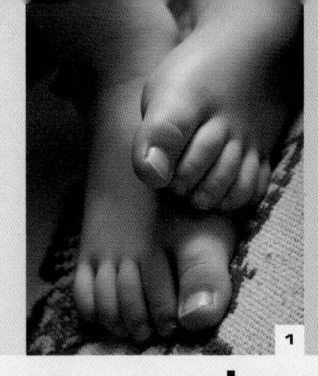

'Know what you are capable of doing in Photoshop before you take the shot. Envision the whole process...not just the capture.'

1

monochrome up close

Arguably a 'different' art form, some say monochrome is easier, and others harder to do well, compared with colour imagery. It is sometimes worth converting an image that is not quite there in colour to black and white, to see if this kick-starts your imagination or simply looks better. Alternatively, some photographers prefer to think monochrome from the off.

shoot

'No Sole' was created by Robert Ganz using a 3Mp digital SLR, fitted with a 50mm f/1.4 lens, while his son was sleeping. Seeing the potential of the interesting lines and shadows made by his feet, Robert decided to take the shot. He was already thinking of it in black-and-white terms when it was taken.

Some cameras offer a black-and-white capture mode, and a few offer a sepia mode as well. Monochrome captures have lower file sizes than colour images (around a third less), thus greater shots within the camera's available storage-card capacity are possible. However, many cameras do not have this in-camera facility to convert to mono, so in this case conversion work needs to be carried out post-capture. Capturing in colour at least caters for all eventualities. Regardless of the route you take, if you get serious about monochrome you can use traditional black-and-white filters to enhance tonal-range effects.

enhance

Once in computer, there are numerous ways to turn an image into mono. We look at a few of the most common options here, using Photoshop. The most obvious is to create a greyscale image, which strips out the colour values leaving greyscale values of the equivalent brightness [Image > Mode > Greyscale]. Once this is done, however, the colour information is lost for good. Greyscale is also ideal in other ways. For example, if you want to add a tint via a duotone, this can be done to a greyscale image, but

not if following other paths to creating a monochrome.

Alternatively, desaturating an image reduces the colours back to mono, but does not remove them completely [Image > Adjustments > Desaturate]. You can, with other options, then tone a shot. Likewise, using hue/saturation [Image > Adjustments > Hue/Saturation] (3), you can set the saturation to –100, then use the colorize option to add tone. The channel mixer [Image > Adjustments >

Typical workflow

> digital capture

> **Power Retouche (PR Studio)**

> desaturate

> unsharp mask

> inkjet print

2 pr studio

1/ The original image, which was shot with mono in mind.

2/ Using Power Retouche (PR Studio) software, images can be desaturated to create black-and-white results.

3/ Reducing the saturation to –100 desaturates the image, creating mono results.

4/ The channel mixer is a flexible control for monochrome. Check the mono box and you can adjust contrast and tonal values. Unchecking the box after an image has been converted to mono enables toning to be introduced via the sliders.

5/ The final image.

enjoy

Some inkjet printers deemed suitable for photo quality can lack sufficient ink types to produce a good tonal range in mono, and prints are best created using around seven separate inks or more. Ideally printers will be specifically developed for black-and-white output.

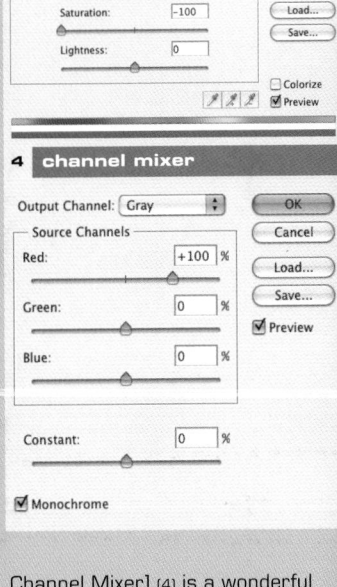

Channel Mixer] (4) is a wonderful way to create black and white. If you check the monochrome box you can then tone a shot using the sliding controls.

Finally, if you decide to filter on camera, once you have converted a colour image to black and white a quick white-point selection using the eyedropper tool in levels or curves [Image > Adjustments > Levels] is often all it takes to clean up an image and give tonal values different to those captured in a shot, without filtration.

1

'This was a job for a patient person! As soon as I found the right angle and the perfect approach, it was gone.'

lab colour

Good composition often comes from patience when reviewing your options. With carefully thought-through manipulation, you can work with the best composition to provide a memorable shot. Here, we look at some useful options not covered elsewhere in the book.

shoot

Utilising a 6Mp entry-level digital SLR, fitted with a 180mm f/3.5 apochromatic macro lens, Norwegian photographer Trine Sirnes Thorne's 'H$_2$O Abstract I' started life from humble beginnings, using an f/3.5 and 1/60sec exposure, made at 100 ISO sensitivity. An earlier compact digital – with its suitability for close-up imagery – allowed Trine to notice and look more closely at small and beautiful details, both in nature and in simple domestic items. This helped motivate her passion for searching out new images of known objects, leading to her 'H$_2$O Abstracts' series.

Created at her home whilst she was looking for something new, something different, and something aesthetically simple to photograph, Trine took a large metal bowl with some water in it, added some dishwasher soap, and placed it in front of a large window. The camera was tripod mounted. A domestic lamp provided the further illumination required for one side of the image. Using a drinking straw to blow a single bubble, Trine hurried to get some close-up shots before it burst. Frustratingly, this was not easy to do: as soon as Trine found the right angle and the perfect approach, it was gone. Patience paid off, however, resulting in this simple and clean, yet elegant and eye-catching composition.

> 6Mp digital SLR

> Photoshop

> unsharp mask

> contrast

> rotate canvas

> eraser

> lab colour

> greyscale

> unsharp mask

> levels

> bubblejet print

! Duotones offer great flexibility to manipulate monochrome images.

enhance

All work was undertaken in Photoshop. The first step was to adjust globally aspects such as unsharp mask and contrast (2). The image did not look its best compositionally, so was flipped vertically [Image > Rotate Canvas > Flip Vertically] (3). Still not happy, Trine then flipped the image again, this time horizontally (4). The untidy background was removed, mainly using the eraser tool, around the bubble's edge, and replaced with a plain black background (5). Next the image

was converted to monochrome. This was converted to lab colour mode [Image > Adjustments > Mode > Lab Colour], selecting the lightness channel, then converted to greyscale with an adjustment to unsharp mask and levels.

1/ At the beginning, shooting the bubbles before they disappeared proved to be a frustrating exercise.

2/ Unsharp mask and contrast were tweaked early on.

3/ 4/ The image was flipped, then flipped again, for a better composition.

5/ The background was changed to featureless black.

why not...

Why not tone a monochrome image? Duotones, tritones and quadtones use two-, three- and four-coloured inks respectively, mixed with black to create tinted greys rather than different colours, often used in high-quality reproduction. A standard greyscale image may show up to 256 levels of greyscale onscreen, but a printing press reproduces about 50 levels of grey per ink. When only black ink produces a greyscale image in print, it loses the smoothness of the original. Adding coloured inks adds around 50 more shades to the printable scale each time, extending the dynamic range of the image. The resulting tint is often pleasing on the eye. When creating a duotone in Photoshop, the image is first converted to greyscale [Image >

Mode > Greyscale]. The duotone option is then activated [Image > Mode > Duotone]. A dialogue box appears (6) allowing selection of colours or manipulation of the component channels through curves for fine-tuning. Double-clicking on a colour or curve enables changes to be selected and used. Duotones are saved in the Photoshop format.

6 duotone options

Type: Duotone

Ink 1: Black
Ink 2: PANTONE Yellow C
Ink 3:
Ink 4:

OK | Cancel | Load... | Save... | ☑ Preview

Overprint Colors...

6/ Duotones, tritones and quadtones can be chosen using two, three or four colours to mix with black. Double click on a colour shown to see the selection swatch.

7/ Duotone or other options such as a tri- or quadtone are easy to select.

7 custom colours

Book: PANTONE® solid coated

OK | Cancel | Picker

PANTONE 871 C
PANTONE 872 C
PANTONE 873 C
PANTONE 874 C
PANTONE 875 C
PANTONE 876 C
PANTONE 877 C

L: 89
a: -4
b: 112

Type a color name to select it in the color list.

lab colour mode

In Photoshop, lab colour mode divides an image into three components. The first is a lightness channel (L), adjusted across a range from 0 to 100, while the other two are colour controls. The 'a' control adjusts colours from green to red, while the 'b' channel is for blue to yellow. These allow independent adjustments using –128 to +127 values when using the Adobe colour picker in Photoshop or, using the colour palette, –120 to +120 (7). The benefit is that

8 channels

Layers | Channels | Paths

👁 Lab ⌘~
👁 Lightness ⌘1
👁 a ⌘2
👁 b ⌘3

lightness adjustments can be made without affecting the colours, and vice versa, and this was a key aspect in creating the final image here (8/9).

8/ Lab colour divides the image into three channels, one for lightness, two for colour.

9/ The final image.

enjoy

This particular image has been exhibited in Oslo's Town Hall after winning third prize in a national photo contest. The print sold as a result of this.

Back at base, Trine has only just started outputting in-house, with an A3+ bubblejet printer.

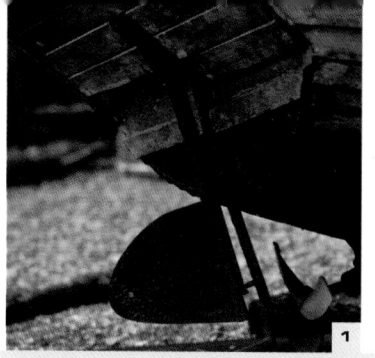

1

! If something is not obvious, and your train of thought hits a wall, leave your workstation and do something else for a while. Your subconscious will still be working on the problem, and often it comes up trumps.

something from nothing

Sometimes images can come out of the blue, for example, when you just happen upon a subject with potential, or when starting out with one aim in mind and ending up with something very different. The latter is often the case if revisiting images you have taken previously.

shoot

A designer and myself were looking to tap into other areas of work. We decided as an exercise to document the small town of Deal, Kent, on the east coast of England. I set off with no intention of shooting any close-up images, thus equipped only with my medium-format camera and lenses. Walking along the beach late in the afternoon I was attracted to some old boats, but time was pressing to get other shots. As we were staying close by, I went out early one morning before breakfast when nobody would be around. I was limited to a short telephoto at its closest focus distance for the shot, which was not ideal, and wished I had packed an extension tube for some wonderful close-ups. Thus this image was shot on colour slide film, which when projected cannot be beaten for its vibrancy and 3D effect.

enhance

> 6x6cm film capture
> Nikon Scan software
> Digital DEE
> 16-bit TIFF
> Photoshop
> levels
> unsharp mask
> clone
> gaussian blur
> desaturate
> colour balance
> crop
> inkjet print

Some years later, having moved almost exclusively to digital for lecture purposes, I wanted to obtain as far as I could an image with similar effects. The original image was scanned using a desktop medium-format scanner and supplied software. I like to set a grid over a preview, which makes it easier to assess an image at this stage before making a final scan (2). After the first scan I decided to do another, this time using dust and scratch removal software (Digital DEE). For both, I also opted to scan as a 16-bit rather than the more common 8-bit image, as there were some tonal values that would otherwise be difficult to distinguish. This doubled the file size, which at the scanner's maximum 4000dpi would have been very large. I opted for a 2000dpi, which still ended up as a 104Mb file – more than enough for numerous eventualities. You might, however, scan at higher resolution if you intend to crop an image dramatically. The resulting digital image was saved as a TIFF file.

Opening the image in Photoshop, and judging the histogram in levels [Image > Adjustments > Levels > Histogram], there was a full range of tones (3). However, experience has shown me that even with this, digital images often need some boost to the contrast as the highlight pixels are often weak. This was done

Settings
Positive
6 x 6 (cm)
Calibrated RGB

W: 4213 pixels
H: 4337 pixels
File Size: 52.3 Mbytes
Analog Gain: Neutral
Digital ROC: Neutral
Digital GEM: Neutral
Digital ICE: Off
Digital DEE: Neutral
SI Enhancer: Neutral
MultiSample: 1x
Bit Depth: 8 bits

R: G: B:

Processed / Natural

1/ The original capture scanned using dust-removal software.

2/ A grid overlay helps concentrate on parts of the image.

3/ Pixel distribution of the scanned image.

4/ 5/ The adjusted pixel-brightness points.

3 levels

Channel: RGB
Input Levels: 0 1.00 255
Output Levels: 0 255
OK
Cancel
Load...
Save...
Auto
Options...
Preview

other (black or white) may need modifying. I had focused on the rusting rudder at capture, so this was again my reference when scanning. At this stage I decided to treat the image as for print, thus some unsharp

mask was required, as this softens the scan (6). This is often a result of dust and scratch removal software being employed.

Though I now had my colour image, I realised that while it

with subtle movement of the white and black sliders of the histogram (4/5), while viewing on a calibrated monitor. It is important to adjust the contrast in small increments, as sometimes only one or the

4 levels

Channel: RGB
Input Levels: 0 1.00 212
Output Levels: 0 255
OK
Cancel
Load...
Save...
Auto
Options...
Preview

5 levels

Channel: RGB
Input Levels: 6 1.00 212
Output Levels: 0 255
OK
Cancel
Load...
Save...
Auto
Options...
Preview

would still fit my needs, it lacked the character of a projected film image. I played around with aspects like removing the bright blue in the background via the clone tool, and adding some selective gaussian blur to try to get even more depth. Then I left it alone, went to lunch, and let my subconscious mull it over. Back at my monitor it hit me – mono. The subject just lent itself to a monochrome. It would be different to my original intentions but perhaps equally rewarding.

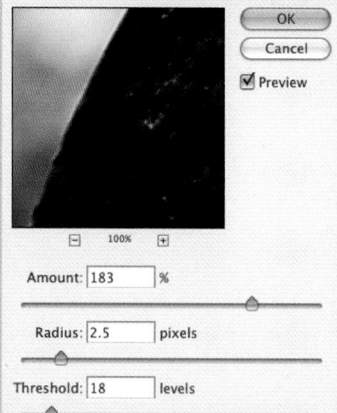

The image was first desaturated [Image > Adjustments > Desaturate] to convert it to monochrome (7). But it lacked the subtle character I was looking for. This was achieved by using the colour balance sliders [Image > Adjustments > Colour Balance] to introduce a subtle tone, enhancing the old-worldly feel of the image (8).

6/ A little unsharp mask was required.

7/ The image was first desaturated to convert it to monochrome.

8/ A subtle tone was achieved using the simple slider controls in colour balance.

9/ The final image.

enjoy

Apart from its reproduction here, the image has been used in lectures and output on a professional inkjet printer up to a 20x20 inch size at 300dpi, with just a small crop from the original's dimensions to make it square.

6 advanced imaging

'Wildflowers' by Deborah Sandidge.

To achieve this vibrant image involved cloning the original flowers then adding painting effects over the top.

in this chapter...

Once the basics and the many useful common touches have been mastered, you can begin to combine imagination with the technical skills you have learned. This chapter focuses on the work of a number of photographers who do just that.

macro post-production

True macro and micro photography requires not just technical skills, but specialist equipment to match. Combine this with professional post-production techniques, and you have the best chance of producing the finest images.

pages 112–115

landscapes of the mind

A subject can be right in front of your eyes, though not always easy to spot. Here we look at an image that fired the photographer's imagination, enabling him to take a subject and, through step-by-step post-production, transform it into something else.

pages 116–119

continue to grow

Sometimes you have to revisit what you have tried or learnt before. This can kickstart your imagination, freeing you from your regular way of thinking, which can sometimes become stale. The surreal image in this section was at first an unpromising capture, but was given a new lease of life post-production.

pages 120–121

layered hair

Using layers is fundamental to advanced imaging. It is a flexible means of adjusting individual components of an image. Whilst this image looks simple enough, it disguises the logical and numerous stages it went through to become the final image shown here.

pages 122–123

raw goodness

A RAW file is our digital negative. While it is tempting to create JPEG files for speed and to keep file sizes small, many types of close-up and macro imagery allow the time to work with the most flexible and adaptable of starting points – RAW data. Here we look at some of its manipulation options.

pages 124–127

smooth tones

The human form is a gold mine of potential close-up imagery. This section looks at turning a straightforward image into a slightly surreal result. A simple but attention-grabbing composition is brought to life post-production using tools not covered in other parts of the book.

pages 128–129

close-up art

Photography and painting are both art forms in their own right. But using available software imaginatively, the first can be made to look like the latter. Here we show one route to such painterly effects.

pages 130–131

mimicking film

In this example we look at ways of creating a film-like appearance in a digital image. Film is still desirable for many images for its recognisable character and atmosphere, and in helping to avoid the sometimes too 'clean' tones of digital capture.

pages 132–133

1

macro post-production

True macro and micro photography offers a host of rewards and challenges. Choice of equipment is as important as with any other type of photography, with specialist kit often a must. Creatures such as the one in the image here, taken by an imaging artist, can make interesting subjects, especially because of their colours and the details in their eyes. The clean background here was what drew the photographer to this particular subject.

> 6Mp digital SLR

> Photoshop CS

> Thumbsplus

> duplicate layer

> shadow/highlight

> colour correction

> copy and paste

> levels

> curves

> layers

> paint

> burn

> flatten

> magic wand

> lasso

> gaussian blur

> sharpen

shoot

Mark Plonsky used a 6Mp entry-level digital SLR for this shot, 'A Half Hover', which was taken in his back yard. Smaller than 35mm sensors are actually an advantage in macro and micro photography as they offer a higher depth of field shooting at equivalent apertures, focal lengths and working distances compared with full-frame options. Once you get into the kind of magnifications we see here, only an SLR with interchangeable lenses and a host of accessories will let you fulfil your vision. For the record this is a hoverfly, or syrphid, roughly 0.5cm in length.

A 2x teleconverter was fitted to the camera, then a 100mm F2.8 macro lens on top of that. But in order to reach the required magnification, a 500D achromatic close-up lens was screwed into the filter ring of the macro lens.

Illumination came from a third-party butterfly bracket, and a reasonably powered flash connected to the camera with an off-camera TTL (through the lens) flash cord. To spread and soften the light, a diffuser was also attached to the flash.

enhance

Around an hour and a half was spent using Photoshop CS and Thumbsplus software. Mark started by trying to recover some of the detail in the highlights (especially on the nose and neck, as well as on the blade of grass perch). For this, a duplicate layer was used, with a lowered opacity to about 85%. Then shadow/highlight [Image > Adjustments > Shadow/Highlight] was used with settings of 0% for shadows, and 15%, 60% and 20% for highlights (3). Colour correction was set at +20, with black-and-white points clipped at 0.01. Mark then selected highlights from within colour range, feathered to 0.5 and copied and pasted to a new layer (4).

Returning to the earlier layer, levels was adjusted after clicking on options (5) and selecting enhance monochromatic

2 | settings

Description	Camera Data 1	
Camera Data 1		
Camera Data 2	Make:	Canon
Categories	Model:	Canon EOS DIGITAL REBEL
History	Date Time:	2004-07-18T04:52:51+01:00
Origin	Shutter Speed:	1/100 sec
Advanced	Exposure Program:	
	F-Stop:	f/9.0
	Aperture Value:	f/9
	Max Aperture Value:	f/2.8
	ISO Speed Ratings:	400
	Focal Length:	100.0 mm
	Lens:	
	Flash:	Fired
		No strobe return detection (0)
		Compulsory flash firing (1)
		Flash function present
		No red-eye reduction
	Metering Mode:	Average

Powered By xmp

(Cancel)

Shadows

Amount: `0` %

Tonal Width: `50` %

Radius: `30` px

Highlights

Amount: `15` %

Tonal Width: `60` %

Radius: `20` px

Adjustments

Color Correction: `+20`

Midtone Contrast: `0`

Black Clip: `0.01` % White Clip: `0.01` %

Save As Defaults
☑ Show More Options

OK
Cancel
Load...
Save...
☑ Preview

Select: ☐ Highlights

Fuzziness:

◉ Selection ○ Image

Selection Preview: None

OK
Cancel
Load...
Save...

☐ Invert

Channel: RGB

Input Levels: `0` `1.00` `255`

Output Levels: `0` `255`

OK
Cancel
Load...
Save...
Auto
Options...

☑ Preview

1/ The original capture.

2/ The shooting details.

3/ Shadow and highlight control.

4/ Colour range selection.

5/ Levels was used to adjust the contrast.

! Take a lot of shots and study the Exif (exchange information format) data to see what worked.

! If you use accessories such as extension tubes or teleconverters, you will need to take into account an exposure factor increase if working

manually. For example, while the Exif data for the image here showed the aperture as f/9, it was actually f/18 because a 2x teleconverter was used.

contrast (6). This route enabled the retention of highlight details even after making the levels adjustment. Cloning and patching tools were used to remove some dust that had been present on the camera's sensor, and to remove the two blades of grass to the left of the image. At this stage, the image was flattened.

Curves were fine-tuned by adding a midpoint with input/output values of 136/121 (7), darkening the highlights further. A layer mask was then produced, with a radial gradient to limit the darkening to the areas where it was needed. Mark also darkened some of the highlights on the perch, with the Paint tool and a soft brush set to darken mode. Global saturation was increased by about +10, and yellows decreased by about the same value. An increase of saturation in the colours of the eye, of approximately +10, was also made. Mark often backs off a little with regard to these types of adjustments, simply by varying the adjustment layers

opacity down to between 80 and 90%. He has learned that a little less is often better in the final image.

Insect details were burnt in using the burn tool, with shadows and exposure set at 10% and a soft brush of the appropriate size for the details involved. Mark then flattened the image again and carefully selected the background (all but the bug and the perch) ready to defocus. For this he chose the magic wand, set at a tolerance

had used an ISO of 400 at capture.

Lastly, Ultrasharpen Pro 3.0, a free filter for 'intelligent sharpening', was applied. This is an interesting program that selectively sharpens different areas of an image to produce a natural, balanced effect, rather than sharpening globally, which can look unnatural.

6 auto colour

Algorithms
- ⦿ Enhance Monochromatic Contrast
- ◯ Enhance Per Channel Contrast
- ◯ Find Dark & Light Colors
- ☐ Snap Neutral Midtones

OK
Cancel

Target Colors & Clipping
Shadows: Clip: 0.10 %
Midtones:
Highlights: Clip: 0.10 %

☐ Save as defaults

7 curves

Channel: RGB

OK
Cancel
Load...
Save...
Smooth
Auto
Options...

Input: 136
Output: 121

☑ Preview

of 15%. This was touched up by hand with the lasso tool, and the selection feathered a little around a setting of 2. The selected area was next shrunk by 2 pixels, and a gaussian blur of 0.5 introduced [Filter > Blur > Gaussian Blur]. However, the blur was not quite what Mark was looking to achieve, thus the gaussian blur value was changed to 1, then again to 2, finally giving a smooth, noise-free background even though he

! Get comfortable in the digital darkroom.

6/ Enhancing monochromatic contrast.

7/ Curves was used to modify and fine tune.

8/ The final image.

enjoy

Mark sells prints through his website, as well as royalty-free electronic versions through www.shutterpoint.com. The image

here was printed at 10x8 inch using a photo-quality inkjet printer on high-quality paper.

1

1/ The original capture.

2/ The cropped and rotated image.

3/ Hue/saturation was adjusted.

4/ Canvas size was increased.

5/ The marquee tool was used to select a specific area.

6/ Colour dodge strengthened the effects in one of the layers.

7/ A large brush with overlay effect gave the detail Bruce wanted in the 'water'.

8/9/ Transform squashed the horizon.

landscapes of the mind

It is so easy to look but not see. This is something photographers need to keep in mind, as 'seeing' can lead to rewarding close-up images. For example, the image here is not what it seems. The process may look involved, but it is a logical and easy step-by-step exercise in maximising the potential of digital manipulation.

shoot

Bruce Aiken is not only the designer for this book, but an accomplished photographer who has always been intrigued by textures and shapes that are created accidentally. This can represent a close-up and macro photography gold mine if you are prepared to look hard. The idea for 'Landscapes of the Mind' came to Bruce whilst he was staring aimlessly at a patch of plaster on the wall of his studio. He began by taking a shot of a small (about 50mm long) area of the plaster using a 6Mp digital SLR.

2

3 hue/saturation

and a feather of 10 pixels, the selected area as well as the edges remained unaffected (5). The top half of the image was then copied and pasted into a new layer. The colour for this layer was then strengthened

> 6Mp digital SLR

> TIFF

> Photoshop

> crop

> rotate

> hue/saturation

> canvas size

> marquee tool

> layers

> colour dodge

> colour picker

> scale

> lasso

> rotate

> healing brush

> eraser

> hue/saturation

> CMYK

! **Never be afraid to experiment and keep an open mind with regard to your destination.**

enhance

The image was first converted from RAW file to a TIFF. In Photoshop, it was then cropped and rotated 180°, taking on a landscape look (2). Hue/saturation was used to move the colours away from the orange/brown of the original capture to something more blue (3). Levels and contrast were left unchanged at this stage, as Bruce wanted to preserve the full tonal gradation. Canvas size was increased [Image > Canvas Size] (4) so that when the top part of the image was selected with a rectangular marquee tool

4 canvas size

5 selection marquee

using colour dodge and an
opacity of 80% (6).

Next, the 'water' section was
selected, as before, only this
time with a feather of just 2
pixels (just enough to avoid a
sharp edge). A suitable blue was
chosen from the colour picker,
and a large brush, with 'overlay'
selected, gave a better colour
whilst maintaining the detail (7).
The horizon line also needed
cleaning up. This was selected
and, using [Edit > Transform >

Scale], was squashed, though in
a vertical direction only (8/9).
The top and bottom sections
were selected next, and nudged
back in touch with each other.

However, Bruce was aware that
some of the clouds showed
strong vertical lines that looked
out of place. The lasso tool with

10

a feather of 2 was used to copy and paste patches to lose the offending verticals. To avoid repetitive patterns appearing, some of the patches were rotated [Edit > Transform > Rotate] before being placed into position (10/11). The image was now almost complete (12), but for a few stray blemishes on the horizon which were touched up with the healing brush.

A little sense of occasion was required as the finishing touch, and a breaking dawn was the obvious choice. To create this effect, a duplicate layer of the sky was created and the colour changed via hue/saturation (13), and the eraser tool with a large brush deleted most of the new sky (14). The resulting red looked more like sunset than dawn, so the yellow hue was increased and the layer flattened to form the final image (15).

11

12

! Bruce's image is destined to be used as a greetings card and will be printed in conventional CMYK litho (as is this book). During the creation process some beautiful blues were achieved, which will not reproduce in print. This is because the **RGB** colours do not identically match those of CMYK. To avoid disappointment, a good precaution is to work with View > Proof Setup > Working CMYK. This allows the computer and monitor to mimic closely the colours that the CMYK process will produce, so that you can see what the final product will look like.

13

15

14

The image was created for enjoyment, and as an experiment in techniques that could be applied in more commercial work. However, it is possible it will also be used in a new range of greetings cards.

10/ 11/ Copying and pasting patches helped retain a natural look.

12/ A few stray blemishes on the horizon were touched up with the healing brush.

13/ A dawn effect was experimented with via hue/saturation adjustment.

14/ The eraser tool with a large brush deleted most of the new sky, and the result was more sunset than dawn.

15/ The final image.

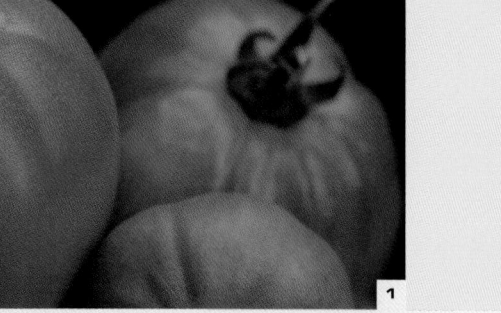

A friend had given me some tomatoes he had grown, but they needed ripening. I have always been interested in fruit as a subject to photograph, with its wonderful textures and shapes, but rarely seem to have the time nowadays to photograph it often. The tomatoes were left on a ledge next to a large window. Passing by a week later my eye was caught by the soft light. Moving in close, I could see wonderful skin detail, colours and, importantly yet often overlooked, deep but soft shadows. I had to take some shots.

The 'Alien Fruit' images were created using a 6Mp digital SLR

continue to grow

Photography is about a lifetime's learning. You can rapidly add to your knowledge base but ultimately, and especially with digital enhancement, there is always more to try. It can also be a case of relearning, as knowledge unused can become knowledge forgotten, as was almost the case with the techniques used for the images here.

2 fresco

1/ The original capture.

2/ Settings for the fresco effect.

3/ The results of the fresco filter.

4/ Colour changes created using hue/saturation adjustment.

5/ The final image.

enhance

The image I finally worked on had less depth of field than some of the others which, although as a 'straight' shot were better, did not provide the challenge of taking something less than perfect and working upon it. My RAW file was initially processed in Nikon Capture 4 and converted into TIFF format, then opened in Photoshop.

While it was a nice soft image, it had too much of a conventional look for my mood. My first thought was to create a monochrome version, and I did play around with desaturation and the channel mixer, though nothing felt or looked right. I have never been one to opt for the numerous filters in Photoshop as a matter of course, and like many, there are only a few I could say I use regularly. Still, having in the past looked at these options and experimented, I decided to do so again.

Unfortunately, when opened in Photoshop, the conversion into a TIFF file restricted the options. This is not unusual, and is dependent on how Photoshop – or other software programs – reads the file data. Having encountered the problem before, I knew I had to go back into Nikon Capture 4 and create a JPEG file from the RAW option instead, which enabled the use of the Photoshop filters.

I particularly like diffuse glow [Filter > Distort > Diffuse Glow], so considered this first, probing the possibilities. Still not happy, I visited fresco [Filter > Artistic > Fresco]. Using the default settings (2) I ended up with a nice image (3). I then continued by playing around with other settings, but eventually stuck with the original, aware that it is easy to overdo it. In this instance, the effect was controlled to give a film-like grain, plus luminance to create an eye-catching image. The

4 hue/saturation

> 6Mp digital SLR

> RAW

> Nikon Capture 4

> TIFF

> Photoshop

> JPEG

> Fresco filter

> hue/saturation

> brightness

> inkjet print

with a 105mm micro lens attached. Using a tripod, I tried various compositions and, after finding the one that looked best when viewed onscreen, I then experimented with differing apertures to achieve differing depth-of-field effects. It was important to get the best angle to avoid excessive specula

highlighting on the skins. The image was captured as a RAW file – my preferred option – using 200 ISO sensitivity, the lowest on this particular camera. I also opted for centre-weighted metering, as the balance of highlights and shadows, with midtone colours, was ideal for this.

enjoy

So far I have output this image only as a small inkjet print. However, I am planning to frame it in either a black or perhaps a dull-blue finish.

! **Secure JPEGs by converting them to TIFF files once you have finished post-production. This stops them from being compressed further and avoids quality degradation through repeated 'Save As' commands.**

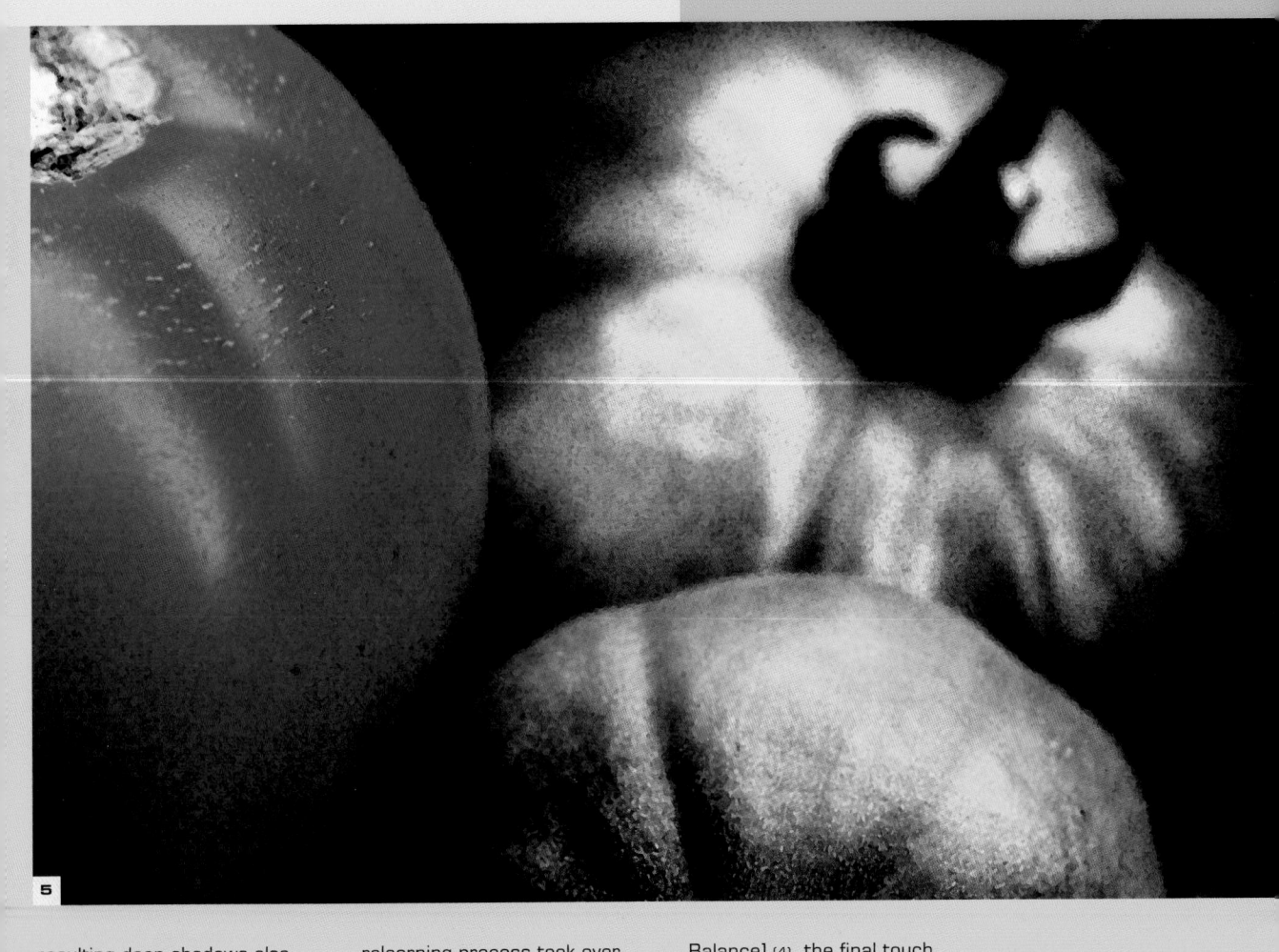

5

resulting deep shadows also added to the impact. But while I was happy with this, I still felt that there were other options yet to be discovered, and this is where the learning, or

relearning process took over. The effect I preferred afterwards was created simply by adjusting the hue/saturation with the colour balance control [Image > Adjustment > Colour

Balance] (4), the final touch being to reduce the brightness by a factor of –10 [Image > Adjustments > Brightness/ Contrast].

shoot

Bruce Aiken took this image at a friend's house using a 6Mp digital SLR. His friend's dog, Tilly, sat quietly on her owner's lap, and it seemed a shame to miss this opportunity for a great shot.

! **Saturation needs increasing when you take the brightness down, as colour tends to desaturate.**

3 hue/saturation

layered hair

2 shadow/highlight

It pays to master layers. Programs other than Photoshop may give this facility a different name, for example 'objects' in PhotoImpact, but the principle is, like many things, simply common sense. Placing components of an image separately, one on top of another, as if on individual clear acetate sheets, means they can be moved around, up and down a stack, or to different parts of the overall image.

Adjustments can be made to the individual layers of an image, thus tone, scale, opacity, sharpness and numerous other changes can be made to specific areas. This approach enables us to truly 'build' an image from its component parts into something better than that we started with.

! **SLRs often accept a reversing ring to mount lenses on back to front. This greatly increases magnification, but you need to work with manual focus and exposure.**

enhance

Bruce first made a duplicate layer [Layers > Duplicate Layer] in Photoshop. Then, to lighten the dog's nose and put more detail back into it, he used the ellipse selection tool, combined with a large feather value (200 pixels) to choose an area slightly larger than the nose. Inversing the selected area [Select > Inverse], he cut out the surrounding area. On to this layer he applied shadow/highlight [Image > Adjustments > Shadow/Highlight], which in some versions of Photoshop is a particularly impressive and useful option (2). In addition, the large amount of feathering used meant that the changes blended in without any sign of an edge.

Another duplicate layer was created from the original and slotted in between the first two layers, with a similar selection process made in order to darken the area below the mouth by adjusting hue\saturation (3). Next an adjustment was made to the background layer to increase the saturation and make the dog appear as colourful as her personality (4). This did not affect the other two layers, and placed the focus on the dog's eyes and nose. Finally, the picture was cropped slightly so that the shape reflected the chunky nature of Tilly's face.

4 hue/saturation

> 6Mp digital SLR
> layers
> duplicate layer
> ellipse
> inverse
> shadow/highlight
> duplicate layer
> hue/saturation
> crop
> mounted print

! The background layer is a blank canvas, or starting image, on or around which you can place other component layers. It can become an ordinary layer by renaming it after double-clicking its position in the layer palette, which controls layers according to the order we choose, and also offers icon shortcuts to features otherwise set from drop-down menus.

Clicking a layer makes it active and ready to work on. Layers usually remain visible, but in order to simplify working on complex images with many layers, you can make them invisible by clicking on the eye symbol next to each one in the stack. If you no longer want a specific layer, drag it to the waste bin icon to remove it. You can also change the positions of layers by dragging them to wherever you choose in the stack. Further refinement comes from linking layers, so their component parts can be moved together. A layer can interact with those stacked below it via layer modes. Blending layers into each other results in a consistent, cohesive result.

1/ Though the original was cute, this image certainly benefited from digital post-production work.

2/ The duplicated layer with the first adjustments. Shadow/highlight proved to be a particularly useful option.

3/ Hue/saturation was used to darken the area below the mouth.

4/ Hue/saturation was also adjusted to make the image as colourful as Tilly's personality.

5/ The final image after cropping.

enjoy

This image was shot and developed purely for pleasure, but a mounted print has been given to Tilly's owner.

5

'For some reason the look of this insect really intrigued me. I really like how he blended in nicely with the leaves. However, for the image I wanted it to stand out, so I used a limited depth of field in order to isolate it.'

1

raw goodness

It can take minute adjustments to get the composition of a close-up image just right. However, one of the joys of close-up work is that, with the exception of insect imagery or perhaps under rapidly changing light conditions, it is not usually time sensitive. And the close-up photographer can even benefit from flat lighting conditions. The control and creative scope with digital post-production makes close-up imagery more exciting than ever, and a **RAW** file is the best place from which to start.

shoot

Photographer Martin W. Quinn is based in the USA. 'Oblong-Winged Katydid' was shot with a 6Mp digital SLR, with a 200mm micro lens attached. Fill-in flash was added, coming from a hotshoe-fitting professional specification unit, set to its D-TTL control. As he shoots RAW files, the size of the resulting files mean that Martin prefers to store them on a 1Gb memory card. In this instance Martin stumbled upon the subject purely by chance while in his backyard.

enhance

About an hour was spent working on the image, mainly in Photoshop. Martin opens up his images using an inbuilt plug-in which enables Photoshop to open up the RAW file. This allows for pre-processing manipulation of the RAW data (2) before using the full Photoshop capabilities. Differing programs and plug-ins offer more advanced manipulation of the basic RAW data than others, so it really is a case of how much detail you want to go into.

Martin next created a new layer for sharpening and adjusting the contrast, making changes using levels [Image > Adjustments > Levels]. Working

1/ The original shot was captured as a RAW file for maximum post-capture control.

2/ A Photoshop plug-in for a RAW file.

3/ Exif data for the original image.

4/ Other programs have facilities similar to Photoshop's excellent shadow/highlight adjustment.

5/ Targeting colours towards different subject types is akin to using films designed primarily for the same reason. No 'one size fits all'.

> **6Mp digital SLR**
> **Photoshop**
> layers
> levels
> unsharp mask
> healing brush
> curves
> flatten
> inkjet print

2 raw adjustments

Camera Model:NIKON D100

Image Size:3008x2000

Exposure Comp.:< Unchanged:0.00 >

0 EV

White Balance:< Unchanged:Auto >

Unchanged

Cancel OK

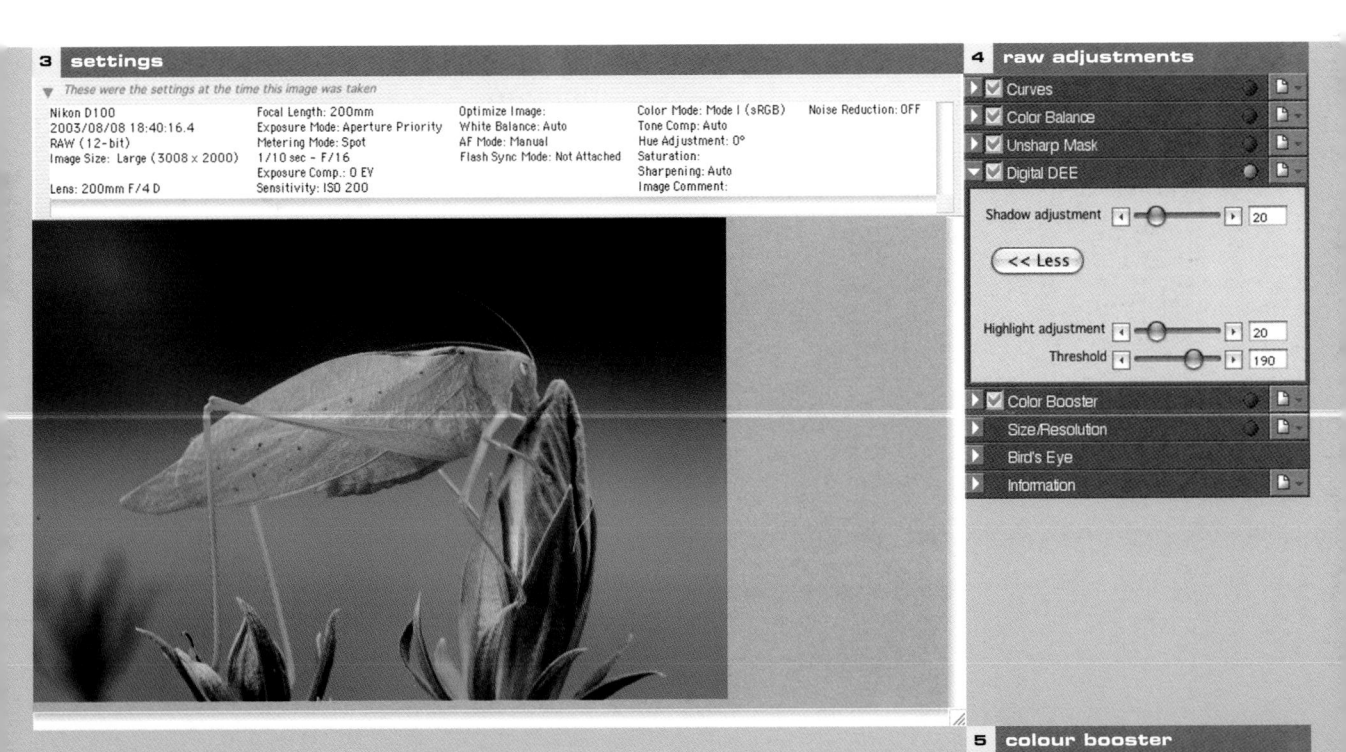

3 settings

These were the settings at the time this image was taken

Nikon D100
2003/08/08 18:40:16.4
RAW (12-bit)
Image Size: Large (3008 x 2000)
Lens: 200mm F/4 D

Focal Length: 200mm
Exposure Mode: Aperture Priority
Metering Mode: Spot
Exposure Comp.: 0 EV
Sensitivity: ISO 200

Optimize Image:
White Balance: Auto
AF Mode: Manual
Flash Sync Mode: Not Attached
1/10 sec – F/16

Color Mode: Mode I (sRGB)
Tone Comp: Auto
Hue Adjustment: 0°
Saturation:
Sharpening: Auto
Image Comment:

Noise Reduction: OFF

4 raw adjustments

- ▶ ✓ Curves
- ▶ ✓ Color Balance
- ▶ ✓ Unsharp Mask
- ▼ ✓ Digital DEE

 Shadow adjustment ◀ —●— ▶ 20

 (<< Less)

 Highlight adjustment ◀ —●— ▶ 20
 Threshold ◀ —●— ▶ 190

- ▶ ✓ Color Booster
- ▶ Size/Resolution
- ▶ Bird's Eye
- ▶ Information

5 colour booster

- ▶ ✓ Curves
- ▶ ✓ Color Balance
- ▶ ✓ Unsharp Mask
- ▶ ✓ Digital DEE
- ▼ ✓ Color Booster

 Target Type: ○ People ● Nature
 Level: ◀ —●— ▶ 52 (Auto)

- ▶ Size/Resolution
- ▶ Bird's Eye
- ▶ Information

with a new layer in this way means that it is quick and easy to revert back to the original image should you not be happy with the effects at any stage in the post-production process. Unusually, Martin likes to use unsharp mask [Filter > Sharpen > Unsharp Mask] early on. Sharpening affects pixel values and can change the look of an image, which is something

Martin does not want to do once he has everything looking the way he wants it to. Values for sharpening the image here were set at 500, 0.4 and 0, for the amount, radius and threshold respectively. Martin finds an area that will show sharpening effects clearly, usually contrasting lines. As much sharpening as possible is applied without this being obvious.

Tidying up included zooming to 200%, and using the healing brush tool to remove dust and other unwanted marks. Levels was then adjusted again [Image > Adjustments > Levels] by sliding the highlight arrow to the left, which increased the brightness of the pixels from the maximum value of 255 down to a value of 200.

Contrast was then further increased using curves [Image > Adjustment > Curves]. Martin does this by eye. It is important to remember, though, that a properly calibrated monitor is fundamental if you do not want to have to adjust prints again by eye after output. Flattening the image kept the file size down [Layer > Flatten Image].

> **!** Always create a new layer before editing – it makes going back to the beginning easier.

6/ Noise reduction is a bit of an art to do well, and not all software programs are the same.

7/ A significant benefit of RAW data is that the shooting criteria can be adjusted later on. Here, the colour mode and tone, as well as hue, have been adjusted.

8/ The final image.

enjoy

> **!** To quickly zoom into an image at 100% magnification, double-click on the magnifying glass icon on the Photoshop toolbar.

This shot was taken for personal enjoyment and has been output on an inkjet printer at 8x10 inch size. Martin feels a dark frame, probably black, will suit it best.

9/ Using the adjustments available in many programs can create different effects without affecting the integrity of the original RAW data. Here, tone adjustments are set for high contrast.

10/ A simple click of the mouse and a low-contrast alternative could be viewed without the necessity for time-consuming adjustments. It is often worth experimenting with RAW file options for ease and flexibility alone. Here, tone adjustments have been set for low contrast.

9 advanced raw high contrast

Advanced RAW

Exp Comp: ◄ ━━━●━━━ ► 0 EV

Sharpening: Unchanged ⬦

Tone Comp: High Contrast ⬦

Color Mode: Unchanged ⬦

Saturation: Unchanged ⬦

☐ Hue Adjustment(originally 0˚)

◄ ━━━●━━━ ► 0

10 advanced raw low contrast

Advanced RAW

Exp Comp: ◄ ━━━●━━━ ► 0 EV

Sharpening: Unchanged ⬦

Tone Comp: Low Contrast ⬦

Color Mode: Unchanged ⬦

Saturation: Unchanged ⬦

☐ Hue Adjustment

◄ ━━━●━━━ ► 0

'I'm very interested in details, and digital close-up photography gives me the possibility to experiment and to create uncommon images.'

1

smooth tones

'Red' is a self-portrait from an award-winning photographer. It combines some lovely touches to give the surreal effects, and shows the importance of imagination and the amazing creative possibilities of applying the many tools and filters within Photoshop.

shoot

Semi-professional photographer Ilona Wellmann captured the image here with a 5Mp digital SLR compact camera, with an exposure of f/2.8 and 1/40sec, using the camera's Program mode and macro

settings. Ilona likes to take images using natural light and often captures the same scene with three different white balance settings so that she can choose the most pleasing.

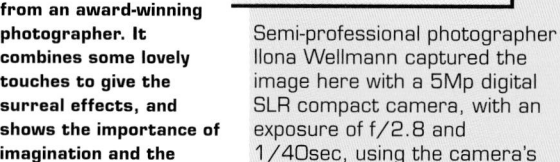

3 | channel mixer

Output Channel: Red

Source Channels

Red: +118 %

Green: +10 %

Blue: −24 %

Constant: 18 %

Monochrome

OK — Cancel — Load... — Save... — ☑ Preview

2 | sponge tool

Brush: 195 Mode: Saturate Flow: 75%

enhance

Ilona uses a variety of manipulation programs, including PhotoShop, PhotoImpact and Paint Shop Pro. For the image here, she spent about half an hour post-capture working in Photoshop. First, the sponge tool was used to desaturate the skin tone around the lips and teeth, set at 75% flow (2). The dodge tool was then used to obtain the white and immaculate skin tone with various exposures between 14% and 55%. The colour of the lips was enhanced using the channel mixer [Image > Adjustments > Channel Mixer] (3), with settings for the red output channel of red +118%, green +10% and blue −24%. Contrast was set at +18%. A Color EfexPro brilliance/warmth filter (plug-in) was then applied,

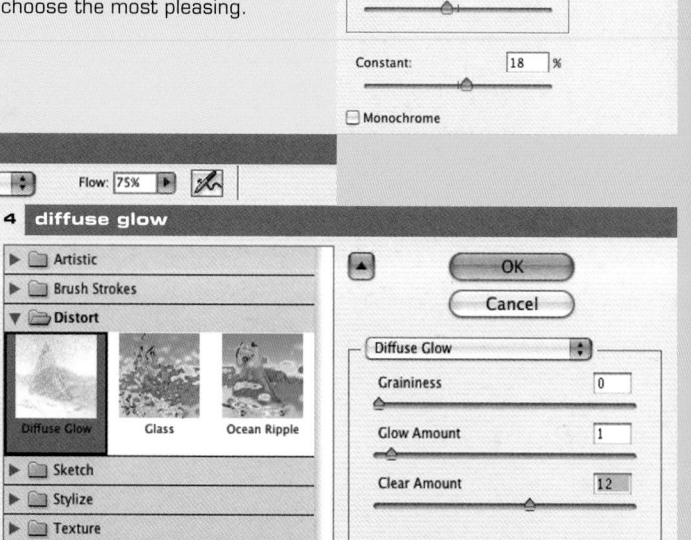

4 | diffuse glow

▶ ☐ Artistic
▶ ☐ Brush Strokes
▼ ☐ Distort

Diffuse Glow Glass Ocean Ripple

▶ ☐ Sketch
▶ ☐ Stylize
▶ ☐ Texture

OK — Cancel

Diffuse Glow

Graininess 0

Glow Amount 1

Clear Amount 12

Diffuse Glow

Diffuse Glow

followed by a diffuse glow filter with values of graininess, glow amount and clear amount set at 0, 1 and 12 respectively (4).

> 5Mp digital SLR
> white balance bracketing
> Photoshop
> sponge
> dodge
> channel mixer
> Color EfexPro brilliance/warmth filter
> diffuse glow filter
> iris inkjet print

1/ A nicely composed and then exposed
original, ready for manipulation.

2/ The sponge tool is simple to use and is
useful for subtle but important
adjustments.

3/ Considered use of the channel mixer
was crucial.

4/ The diffuse glow filter is a wonderful
but often underutilised option.

5/ The final image.

enjoy

Ilona prints for exhibitions. In this
case a 40x30cm iris print has
been produced and framed in red.
The image has also won
competitions and been featured
as the 'Editor's Choice' in several
online contests. It can be bought
through stock agencies.

! *Sponge Tool:* The Sponge tool is
a useful, subtle way to adjust
the saturation of a specific area.
It has its origins in a traditional
'wet' darkroom. It can be used to
lighten (desaturate) or intensify
(saturate), depending on the
mode selected on the options bar.
You can also select the intensity
of the application by adjusting the
flow slider. Once the parameters
are set, the tool is wiped across
the intended area.

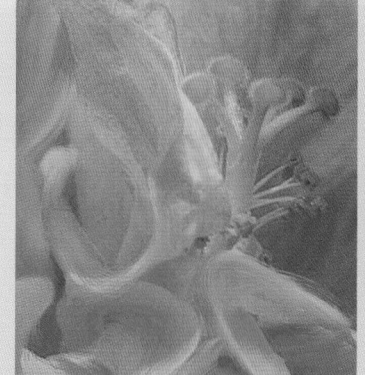

> 'Digital photography facilitates experimentation, enhances my ability to be creative, and provides endless opportunities through multiple manipulation techniques.'

! Back up originals and back up work in progress. Don't be afraid to experiment!

close-up art

While the route to rewarding imagery can be a relatively quick affair, often the most striking results come from spending time accurately capturing the right composition, and in post-production, pushing your creative limits.

shoot

'Tropical' was created by digital artist Deborah Sandidge, who is based in Oviedo, Florida. A 6Mp digital SLR with a 105mm macro lens was used for the image, originally taken in Deborah's front yard. This focal length, or close to it, has been the most popular for macro photography over the years. Today, lenses of this type typically enable a maximum 1/1 reproduction ratio or magnification. Although other focal lengths can achieve the same, the 105mm options enable a comfortable working distance for many subjects, and a fast aperture for ease of viewing under often less-than-bright conditions.

enhance

Deborah used Corel Painter and Photoshop software programs, combining the strengths and unique abilities of each. Time spent on post-production work is dependent not just on the range of adjustments you try, but also on the power of your computer and size of your images. In this case, approximately four hours were spent working in Painter, followed by around half an hour in Photoshop.

First a clone (duplicate) of the image was created in Painter, and then painted over using smeary round oil brushes of varying opacities and sizes (2). As with so many aspects of manipulation, a graphics tablet and pen was fundamental in order to achieve the easiest means of gaining the precision required when 'painting' digitally. Once in Photoshop, the painted image was layered over the original, flattened, then

reintroduced to Painter to add image luminosity (appearance of texture), and finally back into Photoshop for adjustments in curves. Then hue and saturation were adjusted by around +10 (hue) and +37 (saturation) (3).

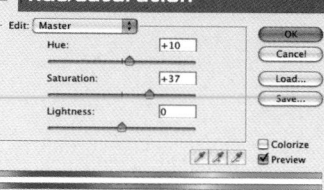

> 6Mp digital SLR
> Corel Painter
> duplicate
> brushes
> Photoshop
> layer
> flatten layer
> Corel Painter
> luminosity
> Photoshop
> curves
> hue/saturation
> inkjet print

3 | hue/saturation

Edit: Master

Hue: +10

Saturation: +37

Lightness: 0

OK
Cancel
Load...
Save...

Colorize
Preview

4

enjoy

Deborah makes her own prints
for her own enjoyment and also
that of others. Her prints are
typically 5x7 inch. Images such as
the one here can sometimes
benefit from the use of less
conventional paper types, for
example giving a watercolour
effect.

5

1/ The original capture.

2/ The effects of painting with a smeary oil
brush in Corel Painter software.

3/ Hue and saturation were adjusted as a
last stage.

4/ The final image.

5/ Because the final image was quite small,
we interpolated the file by 300% using the
bicubic smoother option for the purpose of
reproduction in this book.

'They have a desert plant section where these plants were growing. The lush green and all the layers of these plants were very attractive to me.'

! Adding some noise in Photoshop or other programs into smooth-toned digital images helps create a film-like look.

mimicking film

The area of close-up and its cousins of macro and micro photography is fascinating. Here, we round up with a look at promoting your images and suggestions for selling your wares.

shoot

'Chickens and Hens' is another image from Heather McFarland's portfolio. A 6Mp digital SLR and 60mm micro lens were used for this capture, which was shot on a trip to Meijer Gardens in the Grand Rapids, Michigan, USA. Aperture priority exposure was used, resulting in a 1/125sec shutter speed at f/5.3. However, this included an EV +0.3 adjustment via exposure compensation. This is important with many digital cameras and some metering patterns in order to avoid burning out highlight details. The camera was set at an ISO 400 sensitivity, enabling a hand-held shot, as using a tripod was not permitted at the location.

enhance

Heather mainly works in Corel Photo-Paint and Photoshop. In Photo-Paint, a tone curve adjustment was made (2), while in Photoshop Heather used Fred Miranda's Digital Velvia to increase the saturation. This is so named as it is based on characteristics of Fuji Film's Velvia film, renowned not only for its low grain and high sharpness, but also for its intense colours. It is used to 'lift' an image, for example under flat, low-contrast lighting, and is therefore a firm favourite for shooting close-up and related images.

An additional post-processing step was to clone out imperfections in the plants. In total, the process took around two hours.

! Adjusting the ISO sensitivity of your camera from shot to shot is an underutilised advantage of digital capture.

2 curve adjustment

Channel: RGB Channels

Curve Style:

Null Balance Options...

marx03461

Display All X: Y:

Preview Reset OK Cancel Help

> **6Mp digital SLR**
> **Corel Photo-Paint**
> **tone curve**
> **Photoshop**
> **plug-in**
> **clone**
> **inkjet print**
> **frame**

enjoy

An 11x16 inch inkjet print resides in the photographer's kitchen, mounted in a black frame and matt. This may appear to be an unusual size, but it is one Heather finds is a better match for the image size dimensions the camera catches, reducing cut-off areas to a minimum. However, Heather also gives customers buying her images the option of more conventional print sizes.

1/ The original capture.

2/ Tone curve was modified in Corel Photo-Paint.

3/ The final image.

4/ Smooth-toned digital capture.

5/ Adding noise can create a film-like appearance.

4 add noise

OK
Cancel
☐ Preview

⊟ 100% ⊞

Amount: 0 %

Distribution
◉ Uniform
○ Gaussian

☐ Monochromatic

5 add noise

OK
Cancel
☑ Preview

⊟ 100% ⊞

Amount: 12.5 %

Distribution
◉ Uniform
○ Gaussian

☐ Monochromatic

appendix

'Colorful Jumping Spider' by Mark Plonsky.

As the subject of this image was only about 0.5cm long, a digital SLR, complete with 2x teleconverter and an extension tube were used. Some complex enhancements post-capture took around 45 minutes. The image was printed as a 10x8 inch inkjet print.

Using a digital compact camera fitted with a 250D close-up lens and a diffusing spot filter, Ilona Wellmann shot this image using natural light. In Photoshop, the contrast was adjusted slightly, before outputting as a 40x30cm inkjet print, which was mounted in black, then framed.

glossary

Actions
A series of adjustments and resulting effects made in a sequence. This saves time with repetitive tasks and aids the workflow.

Aliasing
An effect where jagged edges between pixels show when they should be seen as straight or curved. An anti-aliasing filter lessens the effect, as does software using an anti-aliasing process. This reduces contrast between adjacent edge pixels and the resulting jagged look. It requires more unsharp mask to counteract.

Analogue
A continuous signal of information. In the case of film this gives continuous tone. Digitising images results in a non-linear or stepped series of information.

Automatic White Balance
Enables a camera to determine, without user measurement, what should be 'white' in a scene regardless of the colour temperature of the light source.

Bellows
Also called 'extension bellows'. A concertina design enables lenses to be moved closer or further away from an attached camera, changing the magnification. This may restrict the focusing range depending on the lens and bellows design, but micro photography is often possible.

Bit Depth
The bit depth indicates the number of gradations of tone or colour in an image. The higher the number the greater they will be.

Black Point
An eyedropper tool selects a specific pixel brightness level and changes that to a level of zero (black).

Brightness/Contrast
A basic but common adjustment made to digital images. Best use may come from working on a specific area using adjustment layers or similar.

Canvas
This refers to the area of the image that can be worked upon. You can extend or reduce a canvas to change the shape of an image. This is useful for composite images such as when creating panoramas.

CCD

A common type of sensor used in digital cameras, properly called a charge coupled device.

Clone Tool

A popular tool also called the rubber stamp. Used for copying one area of an image into another.

Colour Picker

A means to select a desired colour.

Colour Space

The name given to the location of specific colours in an image based on a theoretical model. Different colour spaces have a larger or smaller gamut to each other. sRGB is smaller than Adobe 1998 for instance, the former more suited to monitor viewing than print reproduction.

Colour Temperature

Measured in degrees Kelvin (K), colours are registered differently by camera sensors and film compared to our eyes and brain. This results in unnatural looking colour with a tendency to warmth or coolness with different light sources, and sometimes other colour 'casts'. A manual or auto white balance measurement is best used at the time of capture to overcome this. Post-capture adjustment can also be made in many instances, especially with RAW data.

CMOS

A Complementary Metal Oxide Semiconductor is a common type of sensor used in digital cameras.

CMYK

An abbreviation for Cyan, Magenta, Yellow and Black. These 'subtractive' colours are used to produce colour in images printed on paper including silver halide, inkjet and magazine reproduction.

Depth of Field

The term describing the range of sharpness from near to far in an image. This increases the smaller the aperture.

Dynamic Range

The range of brightness differences a camera can record depending on its sensor design or film type, between the lightest to the darkest areas. The bigger the differences, the greater the range.

Extension Tube

Accessory for interchangeable lens SLRs. This non-optical tube extends the distance between lens and film or sensor plane. In turn this limits its focus to closer distances but enables a closer focus with the lens attached than normal, resulting in increased magnification.

Feathering

Some selection tools allow parameters to be set to blur edge pixels in an image and smooth the differences between pixels. Also the term used in studio work to describe the edge lighting effect of a softbox fitted over a studio flash head.

File Format

The data that makes up an image can be created in a number of ways. Each is referred to as a file format. The more common ones used in digital imaging are JPEG, TIFF and PSD.

Filter

An on-camera attachment, or software process to modify or enhance an image.

Gamut

The range of colour that can be displayed or printed.

Gaussian Blur

An adjustable filter effect used to soften areas of an image.

Greyscale

The term for black, white and grey shade images absent of colour.

Healing Brush

A variation on the clone tool that helps keep tone and texture looking natural.

Hue/Saturation

A common means to adjust colours and their purity and intensity. In mono, desaturating an image gives it a greyscale look. Reintroducing colour adds toning.

Interpolation

The term used to describe adding pixels into an image, created by sampling information from pixels nearby. Also called resampling. Bicubic is best for most images.

JPEG

A very popular file format that uses compression to throw away data to keep the file size down and speed up writing times. JPEG stands for Joint Photographic Experts Group, the combination of companies who originated the idea.

Lab Colour

A flexible means to work with colour and luminance. The latter is separated into its own channel with colours placed in two others. Any channel can be adjusted without affecting the other two.

Layers

Fundamental to working on complex images, each layer allows specific parts of an image to be adjusted independently of the other parts. Other areas are left unchanged. Flattening layers at the end combines them for the final image.

Levels

A straightforward way to adjust image contrast and tonal range.

Macro Twin Flash
Popular method combining two flash heads, each on an extension arm positioned typically at 45 degrees away from the lens for maximum lighting effect.

Magnification
The term used to describe the size relationship between the subject in life, and the size it is reproduced at on film or a sensor. Also called 'Reproduction Ratio'.

Megabyte
Commonly abbreviated as Mb or MB, a unit of memory equating to 1024 kilobytes.

Megapixel
Written usually as Mp or mp, this refers to a million pixels.

RAW Data
Basic information gathered by a digital sensor and processed by software. This can be adjusted post-capture in the most flexible ways. It is lossless, but RAW files remain considerably smaller than TIFF files. A RAW file is our 'digital negative' and should be treated as such.

Reproduction Ratio
See 'Magnification'.

Resampling
See 'Interpolation'.

Reversing Ring
Suitable for some interchangeable lens cameras, as the name suggests it allows a lens to be mounted with its front nearest to the camera, via an adapter that fits into a filter thread. The rear of the lens in normal use becomes the front. This creates a closer focusing optic and increases magnification.

RGB
The colours of red, green and blue are used to create images in-camera and on a monitor.

Ring Flash
A circular flash head creates 'wrap-around' illumination over the subject. Soft and 'flat', it is ideal for some subjects but not others.

TIFF
Stands for Tagged Image File Format. This lossless option offers a stable image file that can be opened by most imaging applications. However, creating TIFF files in-camera takes the longest time and takes up the most space.

TTL
This stands for 'through the lens'. A measurement made after light has passed through the lens into the camera, rather than one made by a sensor outside the camera.

USM
Unsharp mask is a means to increase and decrease apparent sharpness by adjusting contrast between pixels.

White Point
An eyedropper tool is used to select pixels of a desired brightness value and changes them to one of 255 (white). This can help remove a colour cast in addition to brightening an image.

'Tuna' by Todd Macmillan started life as a simple capture, resulting from a good eye for shape and colour. Todd then adjusted the colour balance, lightness and levels controls in Photoshop, to arrive at the final image.

contacts

Bruce Aiken

Our designer and an accomplished photographer, Bruce uses his photography for greetings card designs. Abstract in nature, they make use of his many years of Photoshop expertise.

Pages 116–119, 122–123

www.aikengraphics.co.uk

Stephen Bonk

Photographer Stephen Bonk comes from Howell, New Jersey, USA. He shoots mainly for his own enjoyment and online photo competitions, but is looking to expand this commercially in the future.

Pages 88–89

sbonk@optonline.net

Terry Bradwick

Terry is a dedicated enthusiast, specialising in close-up and macro photography. He uses state-of-the-art digital capture, with extensive close-up accessories, then Photoshop. Terry lives in Aylesbury, England.

Page 67

terry@tdbradwick.freeserve.co.uk

Tony Georgiadis

Tony is currently based in the Netherlands, but was previously a professional wedding photographer for 20 years in Athens. He now captures everything digitally, then manipulates his images for his own pleasure on computer.

Pages 50–53

georgiadis_1@hotmail.com

Mary-Ella Keith

Mary-Ella is based in San Diego, California. A full-time artist and photographer, her work sells to corporate clients and for private collections. Imagination in her work is vital, as can be seen in her imagery.

Pages 26–27

www.MEBKphotoart.com

Miguel Lasa

Miguel is based in Hartlepool, England. A digital artist and passionate enthusiast, he creates traditional-looking digital images, but with sensible post-production to enhance their visual appeal. Often the best work is that which goes unnoticed.

Pages 20–21, 91

www.miguel-lasa.smugmug.com

Patrick Campbell

Patrick lives in Redding, California. He sees himself as somewhere between enthusiast and professional photographer as he has sold some of his work. His image in this book was created while taking part in a year-long stock-photography class.

Pages 38–39

www.patrickcampbellphotos. com

John Clements

John has many years' experience in the world of photography. His work has been used widely, but he also regularly writes books and magazine articles. He is based in Essex, England.

Pages 92–93, 104–107, 120–121

José Ramón Erezuma

José comes from Spain. His macro images are not only captured with professional care, but with the same level of enhancement in computer. Traditional looking, they nevertheless show digital imaging to a high level.

Pages 46–49

www.photosig.com/go/users /view?id=65350

Duncan Fauvel

Duncan is an enthusiast from Wales. Not only does his image in this book show the world is full of numerous to-hand subjects, it also demonstrates the importance of being able to handle Photoshop or other software well.

Pages 70–71

www.photogo.freeservers.com

Robert Ganz

Canada-based enthusiast Robert has various images in this book showing a number of subjects in close-up, shot not just for his own enjoyment but for contests and, occasionally, for sale.

Pages 44–45, 98–99

www.robertganzphotography. com

Piotr Lorenc

Piotr comes from Tarnów, Poland. A professional photographer, digital photography is his passion, and he has his own studio. He is mostly a people photographer, a subject area that offers huge close-up potential.

Page 37

www.piotrlorenc.com

Marion Luijten

Marion's home is Oisterwijk in the Netherlands. Her work shows a natural beauty in her subjects, which remain 'real', and do not appear to have been manipulated. Even so, Photoshop is important to this artist, so she can tidy up the image after a considered composition and exposure.

Pages 54–55

www.coloursofnature.com

Todd MacMillan

This professional photographer comes from Georgetown, Kentucky, USA. He sells his work to individuals for personal display, using both inkjet and dye sub printed output. His post-production is carried out in Photoshop.

Page 139

www.macmillan photography.com

George Mallis

From Long Island, New York, George is a very accomplished yet self-taught photographer. He has won many awards, and his work has been exhibited widely. His fine art epitomises good capture, post-production and quality printing.

Pages 96–97

www.georgemallis.com

Heather McFarland

A very creative enthusiast photographer, Heather has contributed many images to this book. She comes from Gaylord, Michigan, USA. Her work sells to local fine art dealers as well as being displayed at home.

Pages 14–15, 18–19, 28–31, 64–67, 72–73, 82–83, 132–133

www.hkmphotos.com

Arturo Nahum

Arturo is from Chile. While he describes himself as an amateur digital photographer, he is a very talented one, producing images anyone would be pleased with. His work in this book shows that images are just under our noses and that all we have to do is spot them.

Pages 60–61, 84–85

www.anahum.photopoints.com

Reidar Olsen

Reidar is a digital enthusiast based in Oslo, Norway. He shoots images then manipulates them for his own interest, but also enters them in competitions.

Pages 68–69

www.photoblink.com/net/ms hop.aspx?uid=3798

Martin W. Paul

Edinburgh-based Martin appreciates the close-up capabilities of highly specified digital compact cameras. However, the advanced and step-by-step techniques he uses in Photoshop enable even more eye-catching imagery to be produced.

Pages 78–81

www.photographyten.com

George Perina

Haling from Fort Bragg, California, George is an accomplished professional photographer who shoots underwater imagery. All underwater images are close-up by nature, but you still need creative and technical skills in computer to get the best from them.

Pages 62–63

www.seapix.com

Monika Sapek

Monika is based in Redmond, Washington, USA. Her work is eye catching, combining both good composition and logical post-capture touches. Close-up photography plays a major role in her portfolio of images.

Pages 6–7

www.monika.sapek.com

Trine Sirnes Thorne

Trine is a creative photographer whose painstaking work post-capture is to be admired. She finds inspiration in images of everyday things, however, it is imagination that turns them into something special. She is based in Fredrikstad, Norway.

Pages 100–103

www.SirnesPhotography.com

June Marie Sobrito

New York-based June is an enthusiast photographer. Using digital SLRs combined with a wonderful eye for colour, her images come alive in Photoshop and can be viewed on the Internet.

Pages 76–77, cover image

www.pbase.com/sieeper55

Chris Spracklen

Enthusiast and photo artist Chris lives in Martock, England. Using digital capture and following up with clever Photoshop adjustments, he has sold some of his images and is keen to develop this side of his hobby.

Pages 56–57

Ray Philson

Ray describes himself as an amateur photographer, but that does not do justice to some of his fine, eye-catching imagery. Based in Bristol, England, he prints mostly for his own enjoyment, though some of his work has appeared in local exhibitions.

Pages 24–25

www.photo.philson.com

Mark Plonsky

Mark lives in Stevens Point, Wisconsin. For many, the work of this imaging artist epitomises what macro photography is all about. A digital SLR with specialist accessories adds to his fine technique, then sensible software manipulation creates amazing results.

Pages 112–115, 134–135

www.mplonsky.com/photo

Martin W. Quinn

Martin is a photographer based in the USA. He uses a high-quality pro digital camera and lenses, the latter specifically designed for close-up and macro imaging. His work is printed for personal enjoyment and exhibitions after image manipulation in Photoshop.

Pages 124–127

www.mqphotography.com

Ross Robinson

Ross comes from Comox on Vancouver Island, British Columbia in Canada. A keen amateur, he has an eye for good composition and the need for sensible post-production in computer.

Pages 40–43

rosslynn333@yahoo.com

Deborah Sandidge

Deborah comes from Oviedo, Florida. A digital artist and photo enthusiast, her work naturally combines high-quality capture with creative work manipulating images afterwards. Her images exhibit a painterly effect, which requires patience to do well.

Pages 108–109, 130–131

www.betterphoto.com/gallery /dynoGallByMember.asp?mem =62529

Lou Verruto

Lou was based in Clarence, New York. An enthusiast, he printed his images for personal pleasure as well as exhibitions and, on occasions, for sale. Clever Photoshop usage helped to bring his imagery to fruition. Sadly, Lou passed away before this book was completed. Our condolences go to all who knew him.

Page 11

www.louverruto.com

Ilona Wellmann

Gummersbach in Germany is home to this talented and award-winning digital artist. Ilona is interested in the fine details digital close-up photography allows us to capture, then the possibilities to experiment and create uncommon images with clever post-production.

Pages 4–5, 128–129, 136–137

www.IlonaWellmann. meinatelier.de

Tarence Wong

Tarence is a digital photography enthusiast from Hong Kong. He uses a professional digital camera and specialist micro lenses for the challenging process of close-up photography.

Pages 16–17, 32–33

www.pbase.com/mr_t

Simon Wootton

Simon hails from Edinburgh, Scotland. With the right equipment you can create some wonderful images, but it also takes a spark of inspiration to make them memorable. Using a simple approach in his work proves its worth in the final image here.

Pages 22–23

www.wootton.me.uk

Brian Zimmerman

A professional photographer from Virginia, USA, Brian understandably uses various capture methods. His colourful images show the timeless qualities of shape, line and form, enhanced with post-capture manipulation.

Pages 86–87

www.BLZphotos.com

acknowledgements

It would be unfair if the author took all the credit for a book, as it is most certainly a team effort. I would therefore like to thank AVA Publishing, in particular Brian Morris and Laura Owen, for their guidance and input. They are a great company to work for. Likewise, the skills of Bruce Aiken, as both designer and contributor, were invaluable. My thanks must also go to Caroline Ellerby for her patient editing, and Sarah Jameson for extensive picture research. We hope you enjoy our labours.

Best wishes,
John Clements